IMAGES
of America

CEDAR RAPIDS
IOWA

D1636723

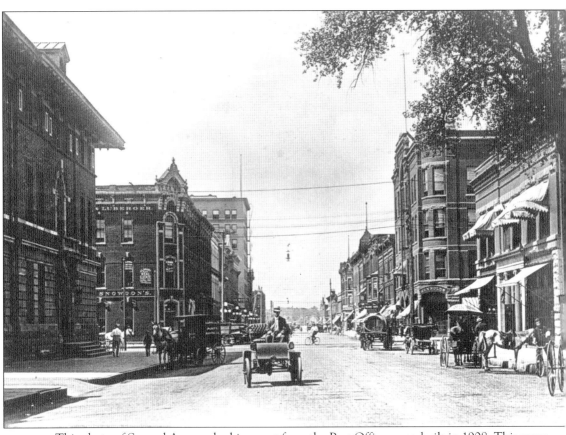

This photo of Second Avenue looking west from the Post Office, as re-built in 1908. This scene shows the active hustle and bustle of a growing downtown. The 1903 Oldsmobile shares the road with bicycles, horses, and wagons. (Courtesy of The History Center.)

IMAGES
of America

CEDAR RAPIDS

IOWA

George T. Henry
and
The History Center

ARCADIA

First Printed 2001.
Reprinted 2002.

Published by Arcadia Publishing,
an imprint of Tempus Publishing, Inc.
3047 N. Lincoln Ave., Suite 410
Chicago, IL 60657

Printed in Great Britain.

Library of Congress Catalog Card Number: 2001093316

For all general information contact Arcadia Publishing at:
Telephone 843-853-2070
Fax 843-853-0044
E-Mail sales@arcadiapublishing.com

For customer service and orders:
Toll-Free 1-888-313-2665

Visit us on the internet at http://www.arcadiapublishing.com

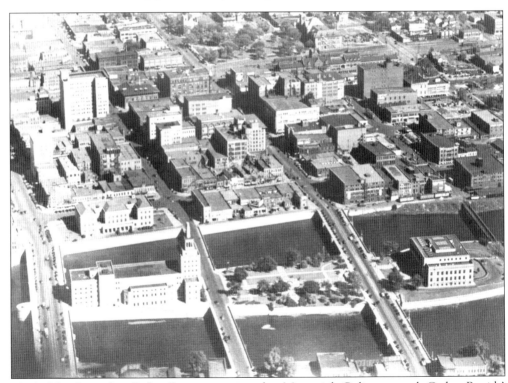

May's Island in the Cedar River contains the Memorial Coliseum and Cedar Rapids' administrative offices, as well as the Linn County Courthouse and Administrative Offices, as this air photo from 1935 shows. The downtown area spreads out on the east side of the river. (Courtesy of The History Center.)

CONTENTS

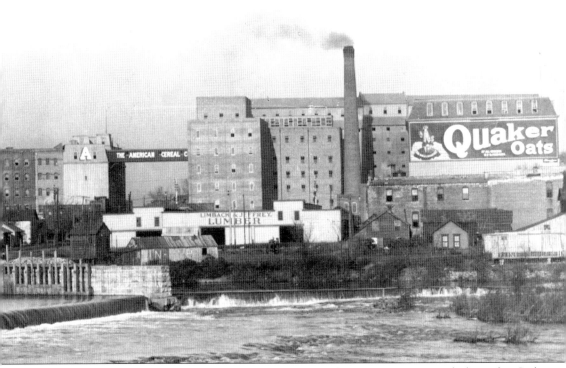

The American Cereal Mill, parent company of Quaker Oats, was situated along the Cedar River at the dam as seen in this c. 1900 photograph. Cereal milling was one of the earliest industries in the city. (Courtesy of The History Center.)

ACKNOWLEDGMENTS

Many thanks need to be given to those who helped with this book. Beverly Redford managed and scanned the image collection used in the book. Cedar Rapids Historian Mark Hunter provided primary research and proofing for historical accuracy. Christina Kastell coordinated the layout and content. Marise McDermott provided editorial assistance. Bob Drahozal provided additional research. Dorothy Anderson typed the manuscript. Kay Henry, George's wonderful wife, gave enthusiastic support.

Photographs were primarily provided by The History Center and from the collection of George T. Henry, Photographer. Additional photos were loaned by Temple Judah, Islamic Center of Cedar Rapids, Rockwell Collins, Mercy Hospital, Dorothy Johnson, the Chadima Family, and Coe College.

INTRODUCTION

Cedar Rapids is governed from an island in the middle of the Cedar River by a commission form of government. No other city can claim the same. One hundred years ago, in 1900, the city was known as "the Parlor City" and the "Queen City" of the great state of Iowa; in this century, Cedar Rapids is known as a "City of Five Seasons." A century ago, Cedar Rapids was known for its massive grain processing plants, and today those plants are even more massive and successful —from cornstarch to corn flakes. Today, Cedar Rapids is known not only for its agricultural products, but also for its communications industries, ranging from radio to avionics manufacturing to telecommunications.

We have taken the last century of photographs and built a story on the contrasts from one period to another, from about the 1890s to the end of the 1960s. We have chosen photographs of places you might remember as life-long residents. If you are new to Cedar Rapids, you can discover its past through these images.

Cedar Rapids' location is a prime area for human habitation, with access to river resources and fertile farmland. The area has a history of more than 10,000 years of occupation of American Indians. Although we have archeological evidence of American Indian life ways, we have no photographs. Even though we have documentation of Euro-American settlers in the late 1830s, we have no photographs of Cedar Rapids at that early stage of development.

In 1842, a plat was filed for Cedar Rapids and the first frame house was built by John Vardy. Population of Cedar Rapids was eight. By 1847, the first school building, post office, and hotel were built. Cedar Rapids was incorporated by the legislature on January 15, 1849.

A chronological tour through the city illustrates how active and progressive Cedar Rapids has been since its early days. Cedar Rapids grew quickly, prospered, and early on, focused on education. The Cedar Rapids Collegiate Institute was opened in 1851. The name changed to Coe College in 1875, and has today a strong tradition of liberal arts education.

In 1856, Cedar Rapids was reincorporated and the first bridge was erected across the Cedar River. Unfortunately, it was washed away during the spring flood the following year. The first train arrived in Cedar Rapids in 1859, amid a large public affair. The first taxes were paid on the lot where the Montrose Hotel stood and the sum was $1.10 on an assessed value of $550. The population of Cedar Rapids had grown to 1,400 by 1858.

Noteworthy buildings like the Masonic Temple and St. Luke's Hospital arrived on the scene in 1884, a year after the *Cedar Rapids Gazette* was founded and published its first evening paper on January 10. Also in 1884, streets were changed from named to numbered and west was added to all streets on the West Side of the river.

The beautiful Union Station was constructed in 1897 on Fourth Street between Third and Fifth Avenue. Facing Greene Square Park, it became a fashionable and impressive entryway

into Cedar Rapids, especially for the 99 passenger trains per day. Mercy Hospital was originally opened in a residence in 1900, but a larger building was constructed in 1903. The Quaker Oats Company plant was destroyed by fire in 1905. The Commission form of government was established in 1908 and the City Council purchased May's Island for park and public building purposes. In 1919, the Douglas Starch Works explosion made national news. The blast was felt for miles around and completely leveled the plant. Also in 1919, voters approved the moving of the Linn County courthouse from Marion to Cedar Rapids and in 1924–5, the Courthouse was built on May's Island.

Construction of the Veteran's Memorial Coliseum on May's Island was completed in the late 1920s, the same time as the Paramount Theater and Mount Mercy College. In 1931, the Federal Building and Post Office was constructed at the corner of First Avenue and First Street SE. The new Municipal Airport was constructed in 1944. In 1949, Veterans Memorial Stadium was completed and Cedar Rapids moved its semi-professional baseball team from Belden Hill Park to the new location. The Kingston Stadium was built for the city's high school football teams. In the 1950s and '60s, new high schools were built, including Washington, Jefferson, Regis, LaSalle, and Kennedy.

During the 1960s and '70s, Cedar Rapids was awash in construction due to an enormous influx of urban renewal funding. This pictorial history focuses on the growth of Cedar Rapids from its early days as a "Parlor City" to its shift as a "modern city" skyline in the late 1960s. Cedar Rapids' progressive spirit produced a great Midwestern city in the first half of this century.

One
CEDAR RAPIDS IN THE
NATIONAL SPOTLIGHT

Cedar Rapids is the city where U.S. Presidents or presidential-hopefuls come to get noticed and where pollsters come to garner the national pulse. The city represents both the urban and rural concerns of Middle America and has been historically on the edge of both the East and "Great West."

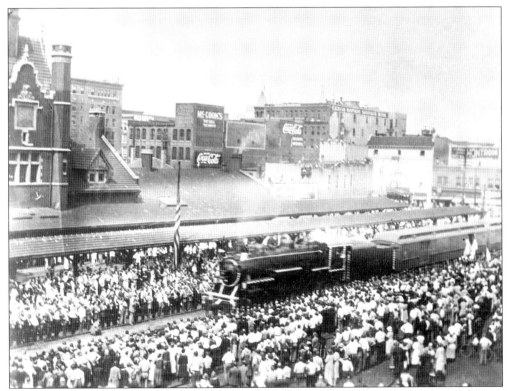

On August 6, 1923, the funeral train bearing the body of President Warren G. Harding passed through Cedar Rapids on the way to Washington D.C. and then back to Marion, Ohio, the final resting place of the president. (Courtesy of The History Center.)

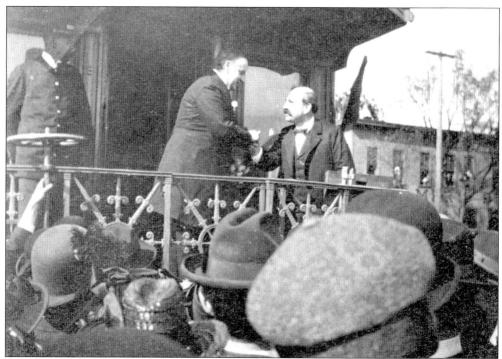

William McKinley, 25th President of the United States, rode the train through Cedar Rapids as he campaigned for office in 1896. John Redmond (on the right), mayor of Cedar Rapids at that time, is shown greeting McKinley before introducing him to the crowd. (Courtesy of The History Center.)

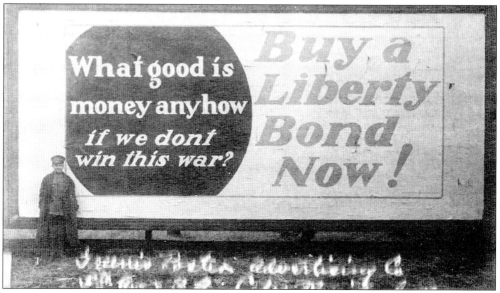

BUY A LIBERTY BOND NOW was a billboard that was seen around the country during World War I. Money from the public's purchase of Liberty Bonds helped equip the soldiers fighting in Europe. The caption reads "Greene's Poster Advertising Co.," which was also in the business of printing Greene's Opera House posters and handbills. (Courtesy of The History Center.)

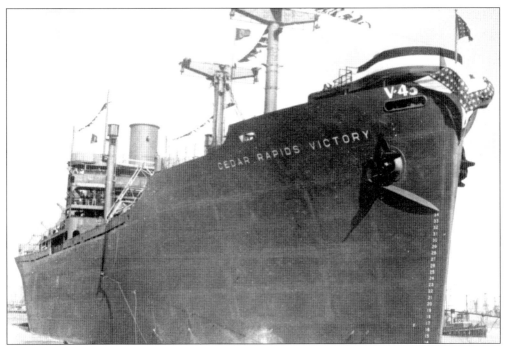

The *Cedar Rapids Victory*, a 455-foot vessel with 10,500 tons of displacement was launched on January 20, 1945. This ship was the 409th ship launched by the California Shipbuilding Corporation and was christened by Mrs. Lena Eveland of Cedar Rapids. (Courtesy of The History Center.)

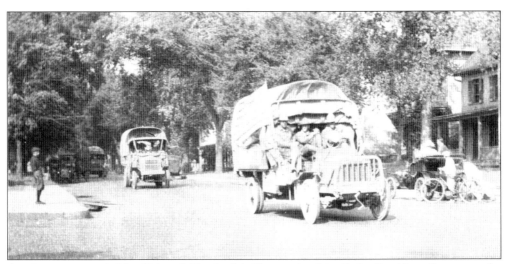

An Army convoy led by Colonel Charles McClure arrived in Cedar Rapids at 5 p.m. on the 23rd of July 1919, having left Washington D.C. on July 7. The convoy was promoting the Lincoln Highway and contained among its members Lieutenant William B. Doron of Cedar Rapids as well as future president of the United States, Dwight D. Eisenhower. (Courtesy of The History Center.)

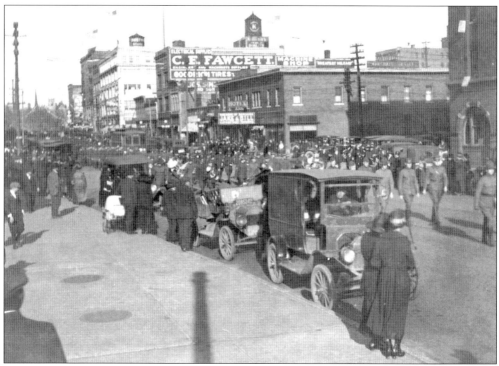

A parade of Army veterans marches down Third Avenue in 1919 to celebrate the Allied victory in World War I. (Courtesy of The History Center.)

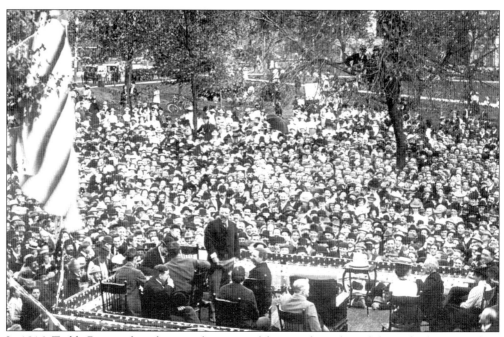

In 1916, Teddy Roosevelt is shown as he stumped for presidential candidate Charles E. Hughes, on a dais erected in Greene Square Park. A huge crowd, with flags waving, was on hand to greet him. (Courtesy of The History Center.)

Two
THE EARLY DAYS

Cedar Rapids is located along the rapids of the Red Cedar River. From its beginnings as an early American settlement, Cedar Rapidians worked at harnessing the river and its tributaries for milling. The excellent prairie land and available waterpower provided resources for grist, saw, paper, and wool mills. One prominent businessman, Sutherland Dows, said about his beloved city, "From the start, Cedar Rapids seemed destined to be what it has become—an industrial city."

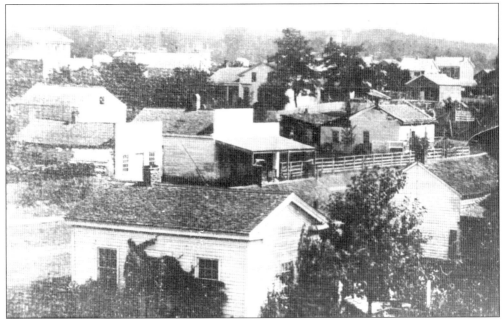

This copy of a daguerreotype shows Cedar Rapids in 1856, when the population was 1,500. The street in the foreground is what is now First Avenue at the intersection of Second Street. In the back left corner is the original Washington High School building. The house in the center back, flanked by trees, is the home of Dr. John F. and Mary Ely, one of the founding families. (Courtesy of The History Center.)

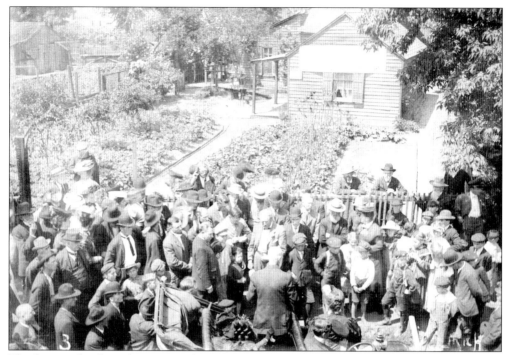

The first wooden frame house in Cedar Rapids was built in 1841 at the corner of Third Street and Sixth Avenue SE by early settler and cabinetmaker John Vardy. This photo of the Vardy House was taken in 1906 for the Semi-Centennial Celebration. (Courtesy of The History Center.)

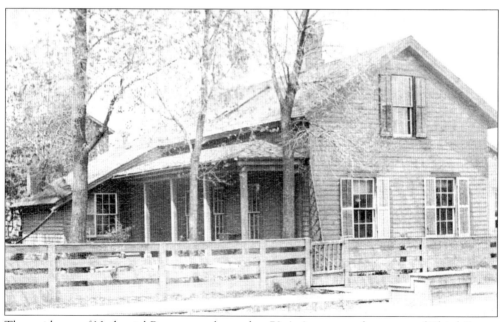

The residence of Nathaniel Bourne was located at 72 A Avenue at the corner of Third Street. Nathaniel Bourne settled in Cedar Rapids in 1861 and was a builder/contractor. His lumberyard, next to his residence, was located on Third Street between A and B Avenues. (Courtesy of The History Center.)

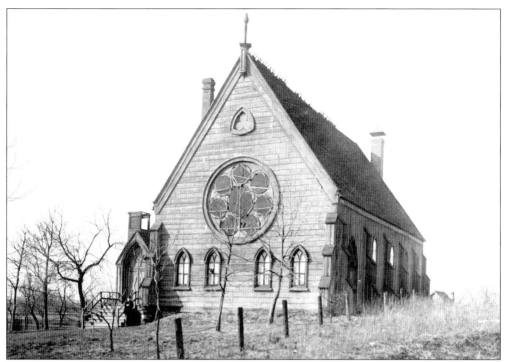

Hope Mission was organized in 1868 under the sponsorship of First Presbyterian Church. The Chapel shown was built in 1878 on the south side of Twelfth Avenue near Fifth Street SE. In 1887, the church became Third Presbyterian. Sadly, the graceful structure burned in 1901. (Courtesy of The History Center.)

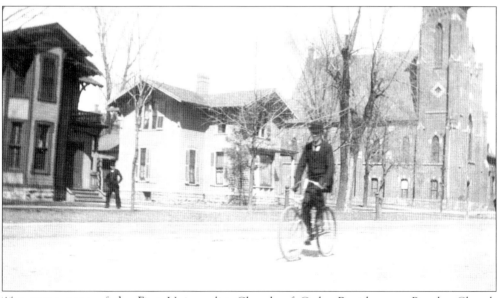

The cornerstone of the First Universalist Church of Cedar Rapids, now Peoples Church Unitarian Universalist, was laid in 1875. It was originally a one-story building, but in 1878 the second story was added. It is shown here about 1900, with Cedar Rapids photographer William Baylis on his bicycle. (Courtesy of The History Center.)

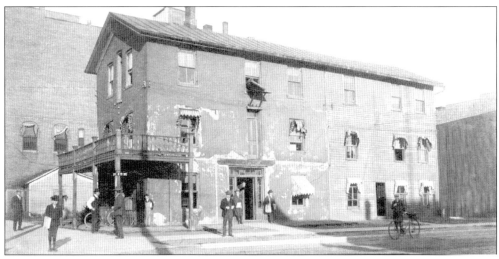

The Empire House Hotel was built in 1854. After an addition was built in 1863, it became known as the Park Avenue Hotel. The building later became a soap factory, and was condemned in 1898. About 1900, it was purchased by the city and after a few improvements, was used as the police station and city hall. The building's condition was so poor that the following popular ditty was composed:

> *He rambled to the Rapids and he saw the City Hall,*
> *And he spoke unto a copper with his back against the wall*
> *He said 'it looks like a stable, you should keep your horses there';*
> *and the copper then replied 'that's where we keep the mayor.*

—Baylis Postcard

On March 1, 1909, the building was sold at auction for $47. (Courtesy of The History Center.)

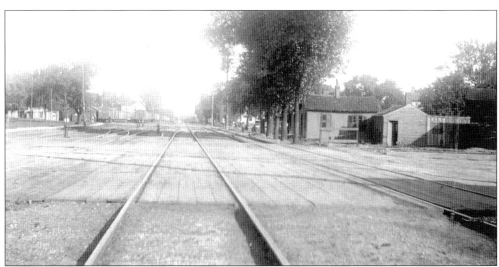

The railroads passing through Cedar Rapids helped ensure prosperity for its residents. Several tracks ran down the center of Fourth Street through town. This *c.* 1880 photo shows the width of the Fourth Street railroad corridor, looking south from near Third Avenue, before Union Station was built. (Courtesy of The History Center.)

This is the home of E.W. and Anna Howell at 237 Second Avenue East in the old numbering system, or 829 in the new. He was the manager of A.E. Howell Millinery. This photo, probably taken around 1880, shows the residential neighborhood with dirt roads and plank sidewalks. (Courtesy of The History Center.)

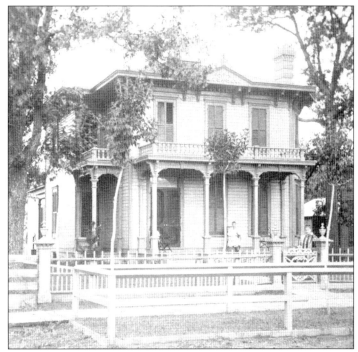

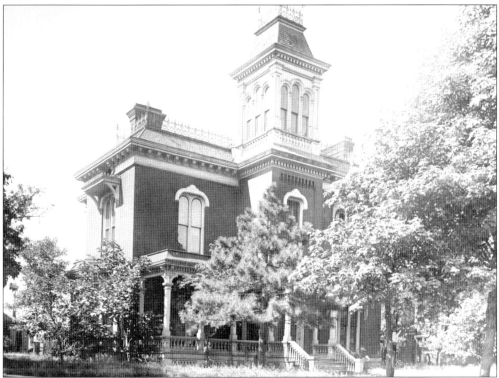

Some of the finest mansions in Cedar Rapids were erected on First and A Avenues, just past downtown. The George Bever mansion at 604 A Avenue was built in the early 1880s. George Bever was in banking and real estate. (Courtesy of The History Center.)

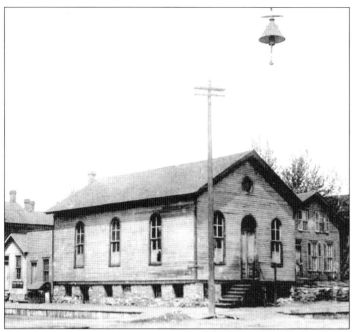

The Salvation Army Hall was located at the corner of Third Avenue and Third Street about 1890, when this photograph was taken. Note the suspended arc street light in the upper right. (Courtesy of The History Center.)

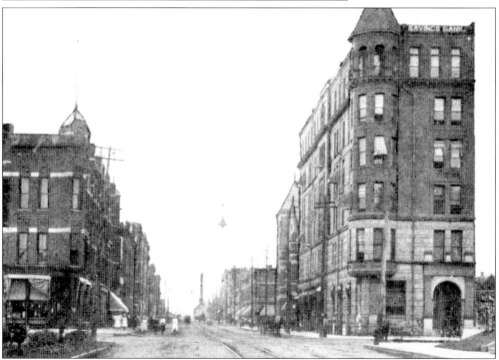

In 1895, the Cedar Rapids Savings Bank was constructed on the site where the Salvation Army Hall once stood. The building held several Cedar Rapids records: it was the largest bank building in Cedar Rapids prior to 1900, the first business building over four stories tall and the first fireproof building of any size. It was designed by the popular Cedar Rapids architectural firm of Josselyn and Taylor. An addition was added to the east side in 1909. The building has housed the Guaranty Bank and Trust Company since 1934.

Three
CEDAR RAPIDS BUILDS AND EXPANDS

The city grew along the East Side of the Cedar River and expanded both east and to the west. The town of Kingston on the West Side of the river was annexed to Cedar Rapids in 1870. The downtown area was for many years framed to the east by the Fourth Street rail corridor. A viaduct was built so traffic and pedestrians could cross the rail lines to residential areas, parks, and the countryside. Elegant hotels were built to house visitors to the growing downtown shops and entertainment centers. Large retail stores attracted visitors from throughout Iowa and the Midwest.

By the 1890s, the city had greatly expanded, with residential neighborhoods growing to the northeast and the southwest. A great deal of development follows Iowa Avenue (later known as First Avenue) toward the town of Kenwood Park, located midway between Cedar Rapids and Marion. The dark lines on the map identify the Cedar Rapids and Marion Street Railway routes. (Courtesy of The History Center.)

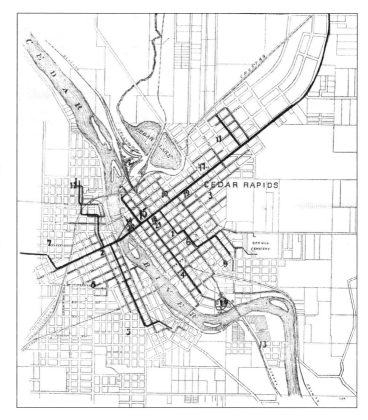

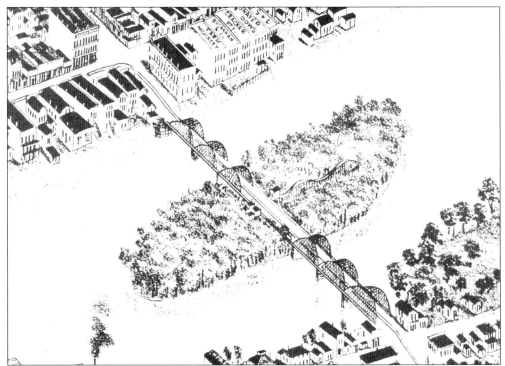

This is May's Island as seen on a birds-eye map of Cedar Rapids in 1889. It was named for former owner Colonel John M. May, who subdivided the island. A roller coaster and dance pavilion were built on the island in the 1880s. Spring floods caused the venture to fail. Several residences and businesses were housed on the island in 1889. The Third Avenue Bridge crosses the river over the island. (Courtesy of The History Center.)

In this c. 1900 photograph, taken from the Third Avenue iron bridge looking south, May's Island is on the left. The island was purchased by the city in 1908 for park and municipal purposes.

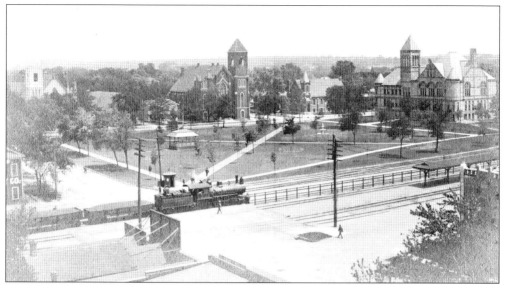

By 1900, more than 200 freight and passenger trains were passing through Cedar Rapids every day. Also, as automobiles became more prevalent and more roads were built, the transcontinental Lincoln Highway through Cedar Rapids helped the community expand and grow. (Courtesy of The History Center.)

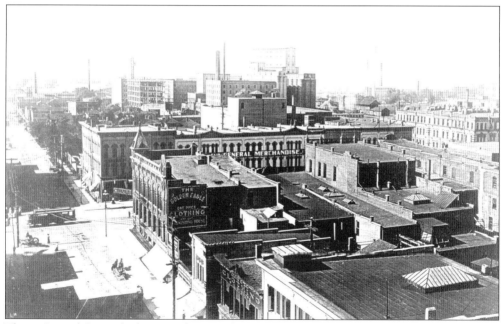

This is Second Street, looking north to Quaker Oats about 1910. The Golden Eagle Building, in the center of the photograph, opened in 1883 and housed the Golden Eagle Department Store. The store was advertised as "The Leading Clothing House in the West" and featured electric lighting fixtures. Note the streetcar running down First Avenue. (Courtesy of The History Center.)

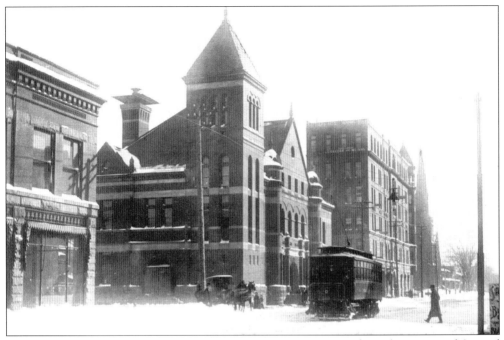

The old Post Office Building (center with tower) was constructed on the corner of Second Avenue and Third Street during the 1890s. In 1908, the structure was completely rebuilt in a different architectural style. (Courtesy of The History Center.)

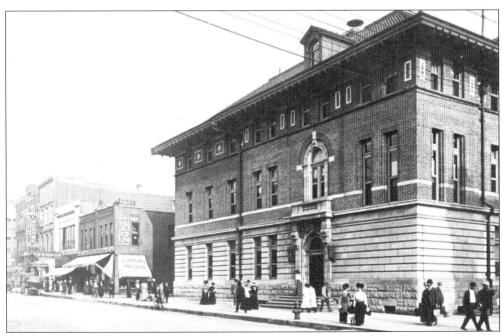

This c. 1912 photo shows the newly rebuilt Post Office Building on the right. Further down the street is the Damour Grocery, which sold baked goods, meat, and chinaware. Damour sold the Fidelity brand of meats, produced by Sinclair Co. packinghouse of Cedar Rapids. The Princess Theater showed moving pictures for 5¢ admission. (Courtesy of The History Center.)

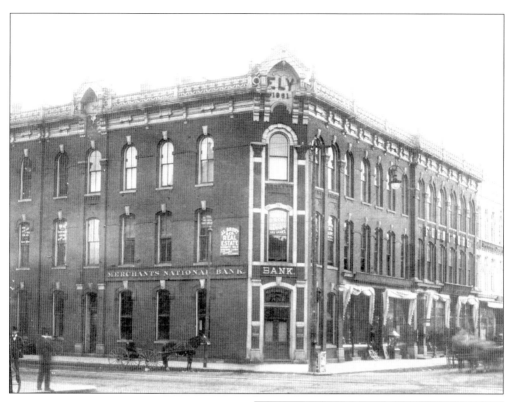

The Merchants National Bank started operations in 1881 on the southwest corner of Second Avenue and Third Street in the Ely Block building. It was established by some of Cedar Rapids' leading citizens of that time: Thomas Sinclair of T.M. Sinclair and Company, George Douglas of North Star Oatmeal Company, S.L. Dows, a prominent businessman, and the Higley brothers, Mortimer and Wellington, who were merchants and real estate investors. (Courtesy of The History Center.)

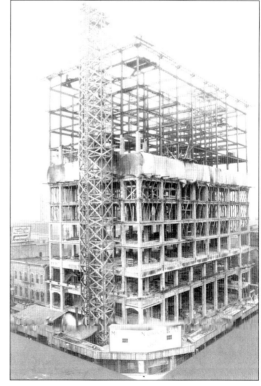

In 1925, Merchants National Bank erected their skyscraper across the street from the Ely Block, on the northwest corner of Second Avenue and Third Street SE. The Globe Hotel is to the left of the bank and Kresge's on the right. (Courtesy of The History Center.)

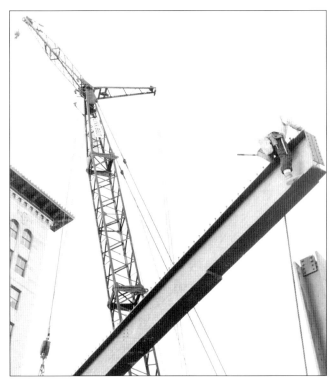

Merchants National Bank added a drive-through banking facility and parking ramp across the street from the main bank in 1962. The Link-Belt crane, a product of the Cedar Rapids company Link-Belt Speeder, lifts an I-beam and worker into the air. (Courtesy of George T. Henry.)

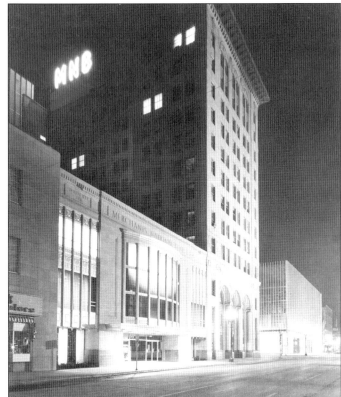

By 1964, Merchants National Bank was complete with the 12-story tower, the drive-through bank, and a new three-story west addition. This photo shows all three. (Courtesy of The History Center.)

The Security Savings Bank, built in 1908 and photographed in 1924, is located at the southwest corner of Second Avenue and Second Street SE. In the background is the Mullin Building, which at that time housed Sanford's and later Montgomery Wards. (Courtesy of The History Center.)

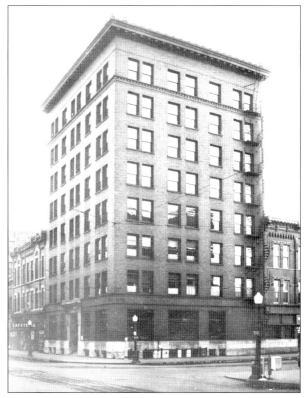

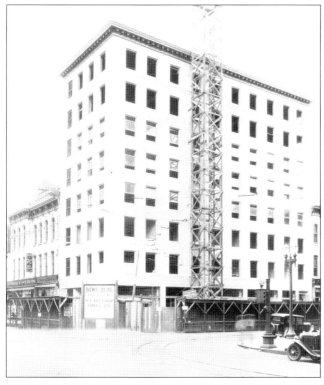

Across the street from the Security Savings Bank, the eight-story Dows Building was constructed in 1930 by the O.F. Paulson Company. The building featured marble walls, mosaic floors, and fine moldings under high ceilings. The Dows family owned Cedar Rapids Electric Light and Power Company, Central Iowa Telephone Company and Dows Maniti Dairy Farms. (Courtesy of The History Center.)

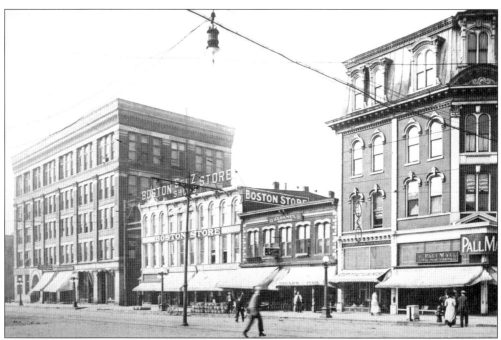

This scene shows the north side of First Avenue between First and Second Streets. The building on the left is the Order of Railroad Conductors and Brakemen (ORC&B). It was the home of the Masonic Temple until 1910. The Union Block building on the right was built in 1870. Notice the optician's sign hanging between the far right second-story windows. (Courtesy of The History Center.)

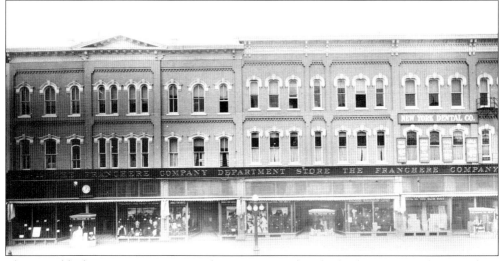

The next block up, on First Avenue between Second and Third Streets, is the Franchere Department Store, originally called The Fair. It was established in 1888 by the Franchere family and was known as the largest retail and mail order house in Iowa. In its heyday, The Fair had 120 feet of frontage on First Avenue and 30 departments on three floors. (Courtesy of The History Center.)

This view up Second Avenue to the northeast was taken just after the turn of the century. The light-colored building in the center back of the photo is the Palmer Building, which housed the Cedar Rapids Business College, built in 1905. The Cedar Rapids Business College was established in 1879 by Austin Palmer, creator of the Palmer Method of Penmanship. He originally worked for an insurance company, but soon realized the need for legible handwriting in business. The standardized handwriting method and other business and office skills were taught at the college. (Courtesy of The History Center.)

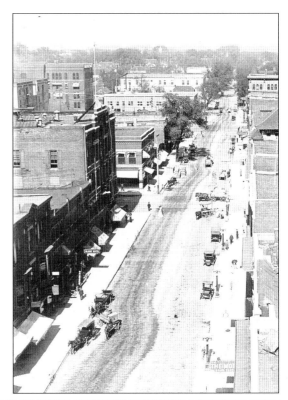

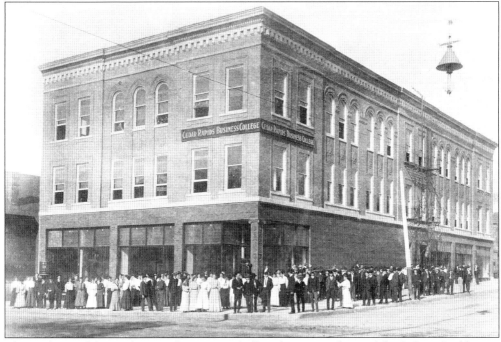

The students of the Cedar Rapids Business College line up in front of the Palmer Building at the corner of Second Avenue and Fifth Street to have their pictures taken in 1906. (Courtesy of The History Center.)

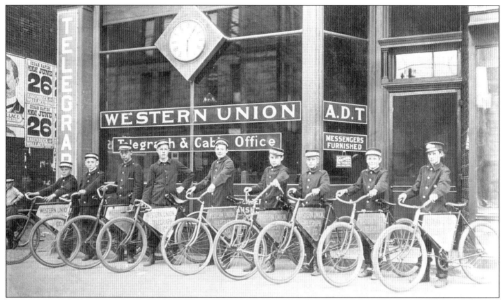

In 1909, the bicycle crew of Western Union messengers line up in front of their office at 215 Third Street SE. When important events happened or when messages had to be sent quickly, Western Union was frequently the preferred messenger, usually in ten words or less. (Courtesy of The History Center.)

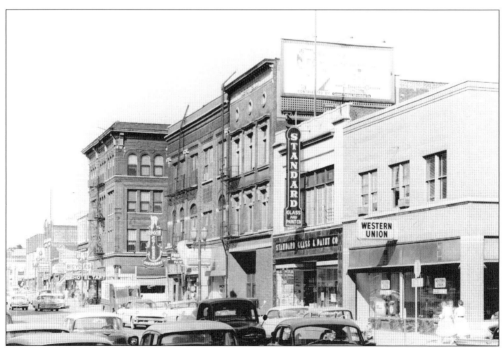

A Western Union office could still be found in Cedar Rapids in 1959 and was located at 315 Second Avenue SE. The businesses next to it are the Standard Glass and Paint Company, the VL Card Shop, the Dragon Chinese Restaurant, and the Taft Hotel on the other side of the tracks. (Courtesy of George T. Henry.)

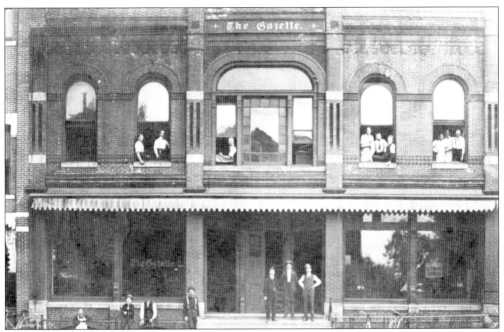

Some of the *Gazette* employees pose in the windows and in front of the Gazette Building in 1910, when it was located at 87–89 First Avenue SE. The newspaper started in January of 1883 as the *Evening Gazette*. It was later sold to Fred Faulkes and his brother-in-law, Clarence Miller. (Courtesy of The History Center.)

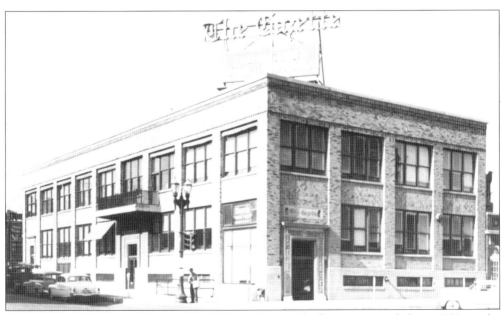

The Gazette Building, constructed in 1925, is photographed as it appeared about 1950 on the corner of Third Avenue and Fifth Street SE, where it still stands today. However, the printing of the *Gazette* has been moved to a larger and more modern facility. The *Gazette* purchased its rival, *The Republican*, in 1927. Although there have been more than 30 newspapers published in Cedar Rapids over the years, the *Gazette* is the only one remaining. (Courtesy of The History Center.)

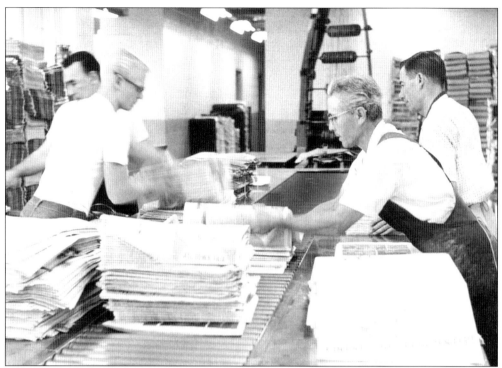

The *Gazette* rolls off the press in the Gazette Building at 500 Third Avenue SE, c. 1950. (Courtesy of The History Center.)

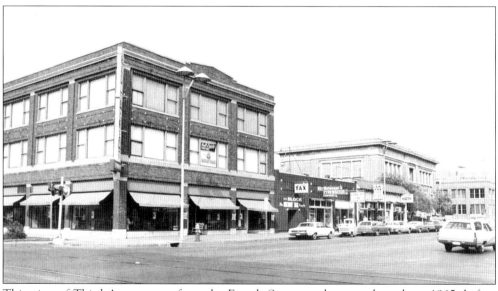

This view of Third Avenue east from the Fourth Street tracks was taken about 1965, before several buildings were torn down to make way for the Cedar Rapids Museum of Art. The building second from the right is the old Carnegie Library, which was incorporated into the design for the art museum building in 1989. The library had been built in 1904, and its second floor housed the city's first art museum. (Courtesy of The History Center.)

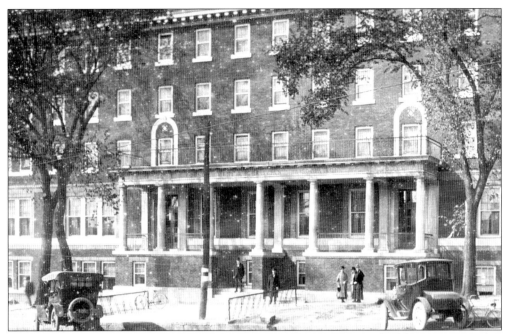

The Cedar Rapids YMCA was organized in 1868. In 1888, the first Y building was erected at the corner of First Avenue and First Street and had a swimming pool, gymnasium, auditorium, library, lounge, and rented rooms. In 1918, the Y moved to the building pictured at First Avenue and Fifth Street. (Courtesy of The History Center.)

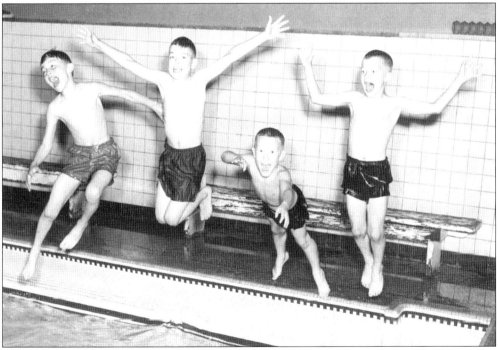

Children swim and frolic in the 20-yard-long YMCA pool in this photograph taken about 1950. (Courtesy of George T. Henry.)

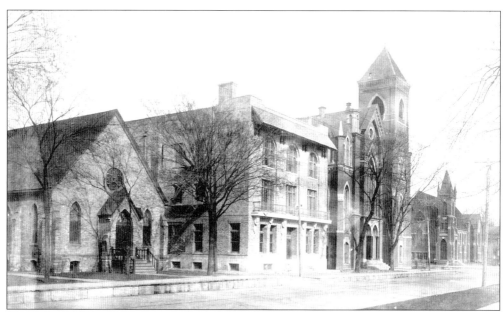

The YWCA is seen here between the First Presbyterian Church Chapel and the old St. Paul's Methodist Church, across from Greene Square with the First Christian Church at far right. The YWCA, located at 318 Fifth Street SE, was built in 1911 and is still in use today. (Courtesy of The History Center.)

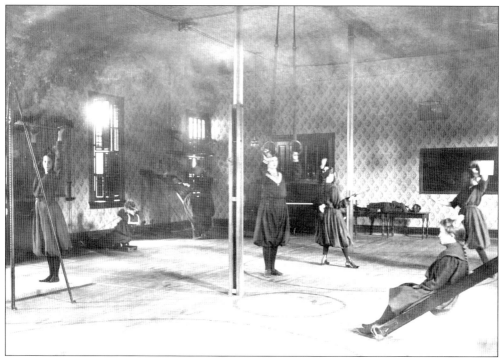

As early as 1899, the YWCA provided exercise facilities promoting the physical fitness of women. This view of the gym on the upper floor of 110 S. Third Street shows girls engaged in fencing, weight lifting, and gymnastics. (Courtesy of The History Center.)

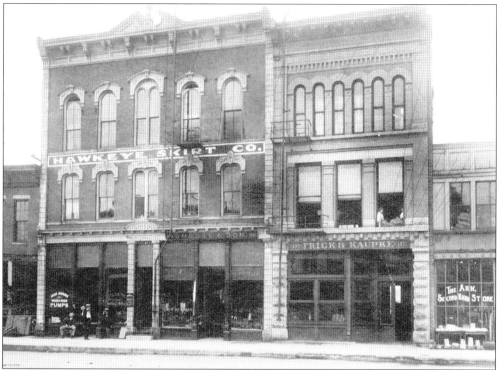

The Hawkeye Skirt and Garment Company was located at 119–121 First Street SE about 1910. The company manufactured suits, jackets, coats, and skirts. Their designs were interpreted from fashion plates received from Paris, providing women with the most up-to-date styles available. (Courtesy of The History Center.)

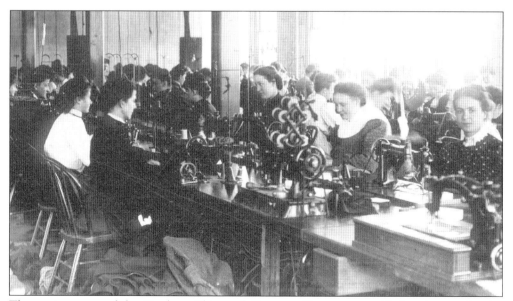

The sewing room of the Hawkeye Skirt and Garment Company was likely a busy and noisy place, but was advertised as sanitary as compared with sweatshop factories. (Courtesy of The History Center.)

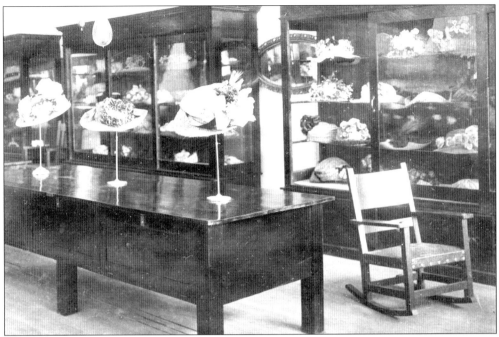

The Lyman Brothers Millinery Shop, a hat factory, was established about 1890. This photo shows the 1912 showroom floor of the building located at 213–217 Third Avenue SE. As many as 125 trimmers were employed to complete elaborate millinery creations like those shown here. (Courtesy of The History Center.)

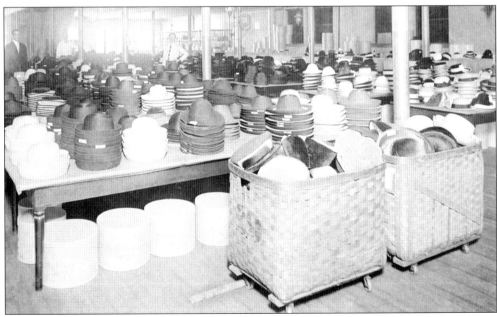

The huge quantity of hats produced by Lyman Brothers is shown in this photo of the warehouse floor. Stacks of unadorned men's and women's hats are shown on long tables, waiting to be packed. Hats with simple hatbands are stacked on the table at the right. (Courtesy of The History Center.)

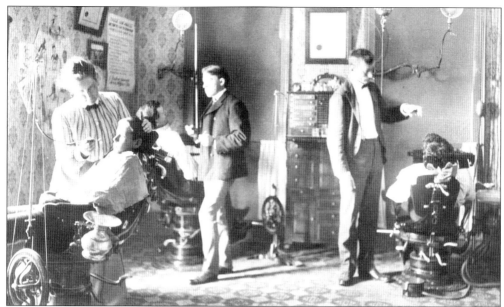

A dental office in 1900 looks crowded and over-decorated compared to those of today. In a profession that was dominated by men, it is very unusual that Cedar Rapids should have had a woman dentist 100 years ago. Jessie Ritchey DeFord (left) and her husband William H. DeFord (right) had their office in the Granby Building on the corner of Third Avenue and Second Street. (Courtesy of The History Center.)

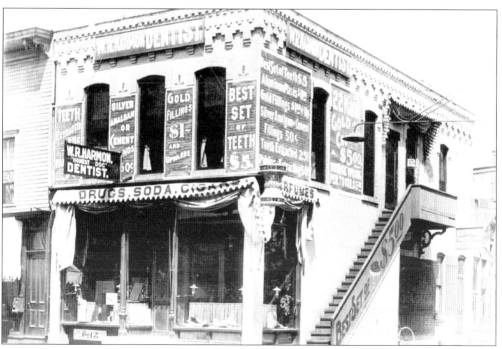

At 100 Third Avenue West, the Boyson Drug Store mortar and pestle sign is lost among the blazing advertising of W.R. Harmon, the "honest doc" dentist, located on the second floor of the building. (Courtesy of The History Center.)

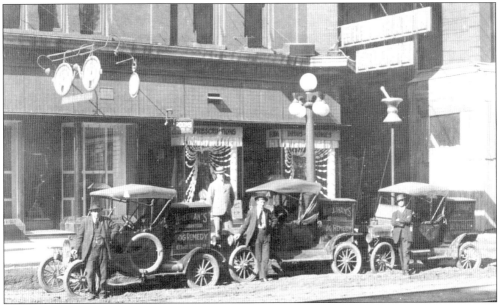

These early pickup trucks are parked in front of Whelihan Drug Store at 217 Third Street SE about 1915. The signs on the trucks advertise Whelihan's Guaranteed Hog Remedy. The mortar and pestle pharmacy sign hovers underneath the Whelihan sign and an optician's sign hangs over the doorway on the left. (Courtesy of The History Center.)

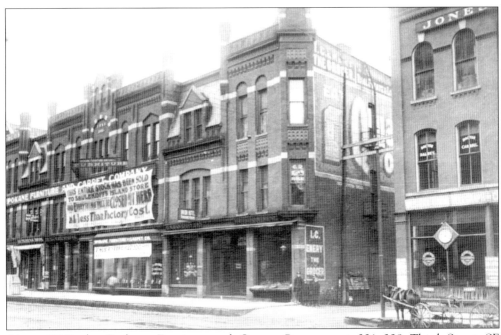

About 1910, the Spokane Furniture and Carpet Company at 221–229 Third Street SE advertised that their huge inventory of $27,000 worth of goods has been sold to Smulekoff's Island Store and will be sold at less than factory cost. The store sold furniture, stoves, carpets, draperies, crockery, lamps, picture frames, and more. It was advertised that everything needed to completely furnish the home could be bought from Spokane. (Courtesy of The History Center.)

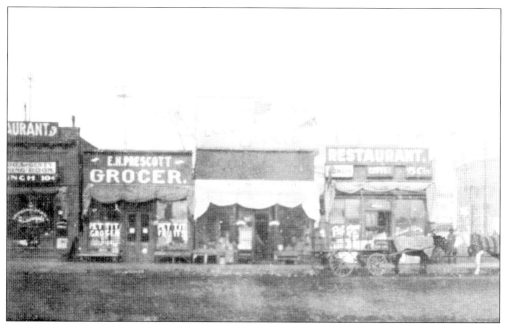

The east end of the business block of Third Avenue SE between Third and Fourth streets is pictured about 1905. G.S. Lazio, next to E.H. Prescott, sold every variety of California fruit, candies of every flavor, and both imported and domestic cigars at his grocery store. William Sleight's lunchroom attracted customers by selling coffee for 5¢ a cup. (Courtesy of The History Center.)

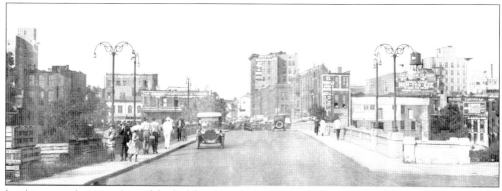

Looking to the east from May's Island and the Second Avenue Bridge, the wild array of advertising on the buildings along the riverfront can be seen about 1924. In the background is the Security Building, home of the Security Savings Bank, on the corner of Second Street, where interest rates of 4 percent on savings could be found. (Courtesy of The History Center.)

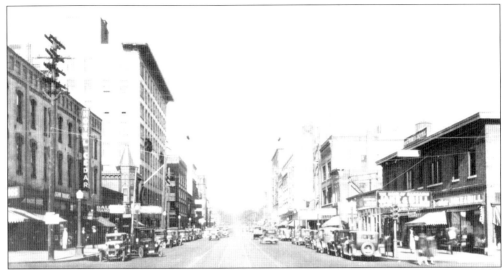

Seen on Third Avenue to the east in 1928 is the Victoria Hotel, a walk-up hotel above Jake & Bill's Home of Bargain, the Capitol Theater (which later became the Paramount), Killian's across Second Street, and the Montrose Hotel. On the opposite side of the street are the Higley Building and the Granby Building. (Courtesy of The History Center.)

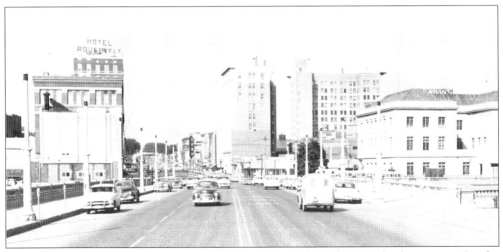

This 1960 view from May's Island on First Avenue reveals Cedar Rapids' skyscrapers. On the left is the Roosevelt Hotel, the American Building is on the right side of the street in the middle of the photo and Merchants National Bank is at the far right on Second Avenue. Far down First Avenue at Third Street is the Iowa Theater sign, which resembles a giant ear of corn. (Courtesy of The History Center.)

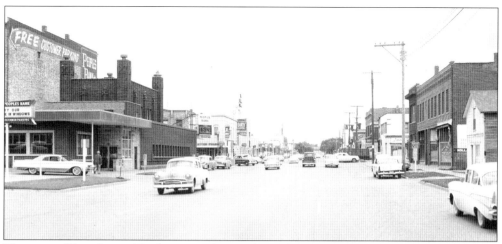

This view of First Street SW shows People's Bank as it looked in 1965. The building, completed in 1911, was designed by Louis Sullivan and was described in the Architectural Record of January 1912 as "the most interesting event which can happen in the American architectural world today." (Courtesy of The History Center.)

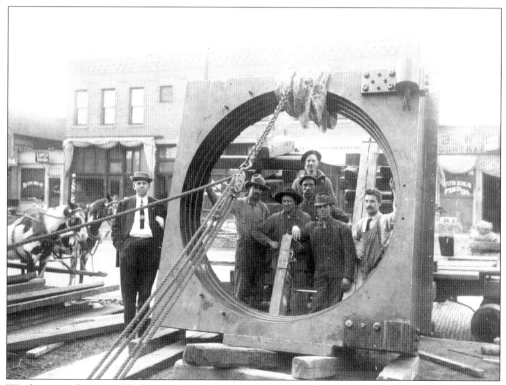

Workers are shown with the vault doorframe prior to installation in the People's Bank vault in 1911. The circular vault door measured 7 feet in diameter, was 22-inches thick, and weighed 25 tons. (Courtesy of The History Center.)

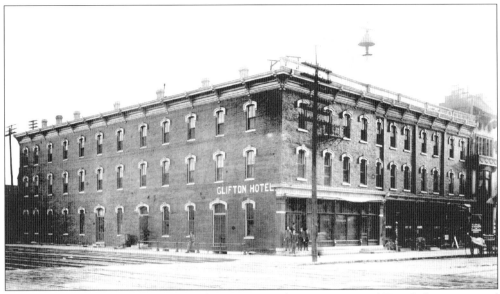

The Clifton Hotel, located on the southwest corner of First Avenue and Fourth Street, opened in 1886. It contained 75 guestrooms, furnished in the most elegant style, with gold paper on the walls and velvet carpet. Here the Clifton is shown as it appeared about 1900. (Courtesy of The History Center.)

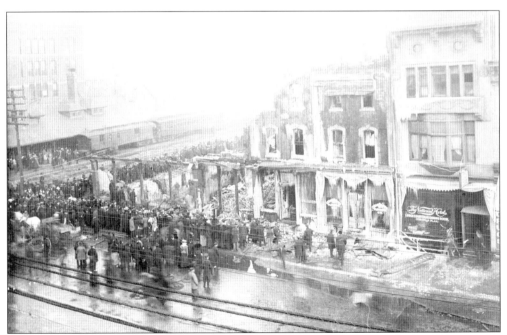

The Clifton Hotel was destroyed by fire, which began about 1:30 a.m. Friday, February 20, 1903, resulting in the loss of seven lives. The fire escapes did not have extension ladders to reach the ground, so many hotel guests had to wait for the firemen's ladder, or jump for their lives. Several guests escaped over the roof of the Cedar Rapids Plumbing Company next door and into the adjacent National Hotel. (Courtesy of The History Center.)

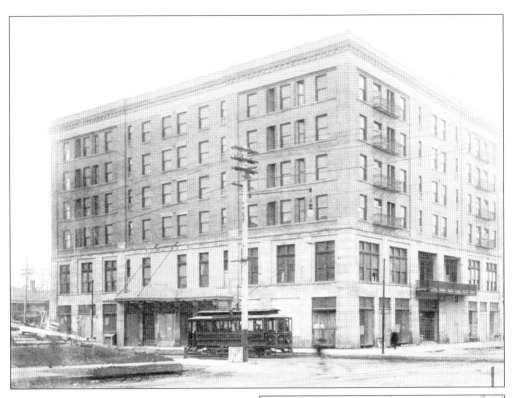

The Montrose Hotel, another large hotel in downtown Cedar Rapids, opened in 1905 at Third Avenue and Third Street SE. This photo shows the hotel shortly after it was built. It was originally six stories high, but a seventh floor was added in the 1920s. All the guestrooms had running water and washbowls, and over half had private bathrooms. The Crystal Ballroom was an elegant location for many social events. During the 1930s, Grant Wood decorated the Corn Room and the mezzanine with murals of Iowa farm scenes called *The Fruits of Iowa*. (Courtesy of The History Center.)

The WMT radio studio moved to the seventh floor of the Montrose in 1934, and a tower was erected on the roof with the station call letters in neon lights. The Montrose closed its doors in 1981, but the tower remained as a Cedar Rapids landmark until the hotel was demolished in 1988. The sign was rescued and moved to the History Center by the Coonrod Wrecking and Crane Service. (Courtesy of The History Center.)

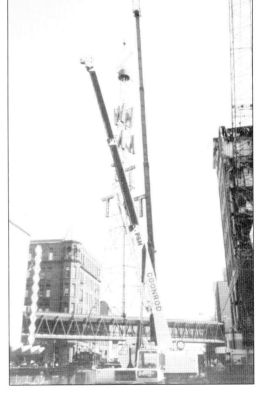

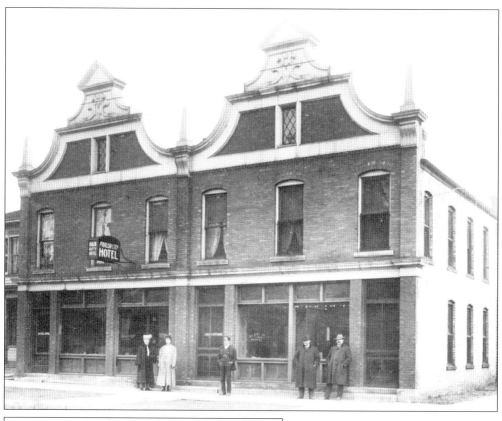

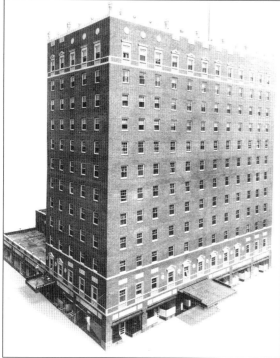

The Parlor City Hotel opened in 1903 at 207–11 Fourth Avenue, just a few blocks from the Union Station passenger depot. The hotel boasted 30 rooms, a dining room with 50-person capacity, steam heat, electric lights, and baths. The room rate was $1.50 per day. (Courtesy of The History Center.)

The Roosevelt Hotel was constructed on the corner of First Avenue and Second Street NE by financier Edith Rockefeller McCormick, and opened August 15, 1927. It featured 241 guest rooms, three public restaurants, and the Roosevelt Ballroom. Due to the financial climate of the times, the hotel went bankrupt in 1932, but was purchased by the First Avenue Company, headed by the Cook family of Cedar Rapids and operated until 1975. (Courtesy of The History Center.)

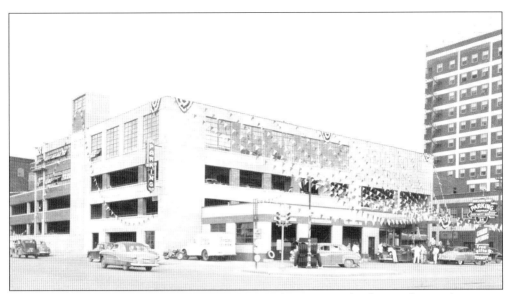

About 1951, at the corner of A Avenue and Second Street NE, the first modern parking ramp built in downtown Cedar Rapids was opened by Robert Armstrong, along with Jack Hatt's service station. The parking was used for Roosevelt Hotel customers before their own ramp was built in 1966. (Courtesy of The History Center.)

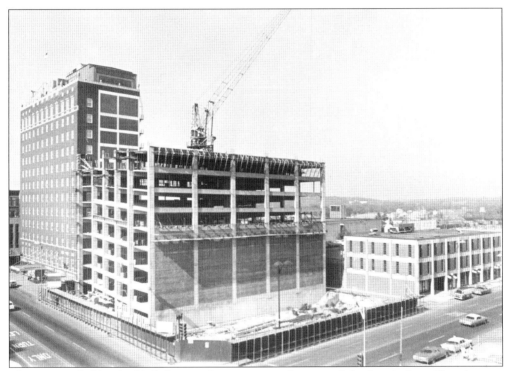

The Roosevelt Hotel added their parking ramp to the east of the hotel along First Avenue about 1966 and became a "drive-in hotel." To the north along Third Street NE, where the Majestic Theater once stood, is the Professional Park Building. (Courtesy of The History Center.)

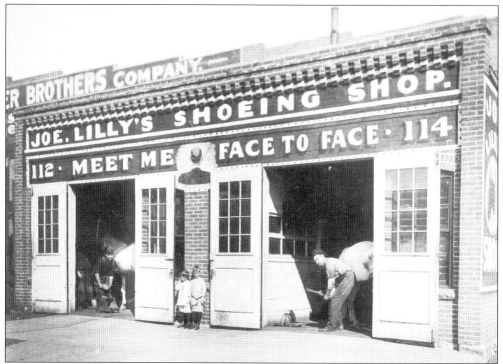

Children pose in front of Joe Lilly's Shoeing Shop at 112–114 Fourth Avenue, about 1905. Joseph Lilly established his blacksmithing business in Cedar Rapids about 1887, and built the shop pictured in 1902. He employed five men and carried a complete line of hand-made horseshoes. (Courtesy of The History Center.)

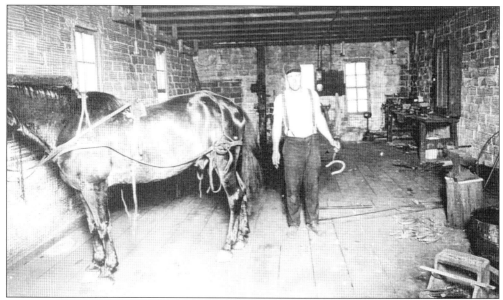

Blacksmith Charles W. Browning is in the process of shoeing a horse at his blacksmith shop located at 124 H Avenue NW in 1922. Even though automobiles had become very popular by this time, the horse continued to be a mode of transportation. (Courtesy of The History Center.)

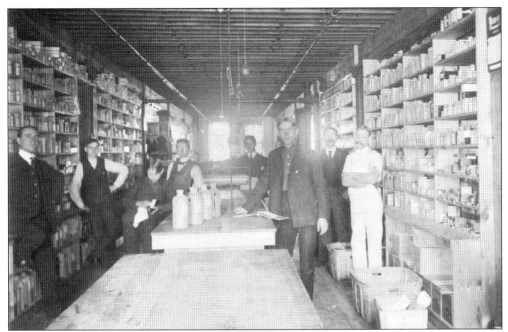

The Churchill Drug Company was a wholesale company established in 1902 in the Sinclair Building at the corner of First Street and Third Avenue. The business occupied five floors and the basement. An aisle in the order room is shown with bottles and crates lining the walls. Churchill was known as possessing "one of the most complete stocks of drugs in the west." (Courtesy of The History Center.)

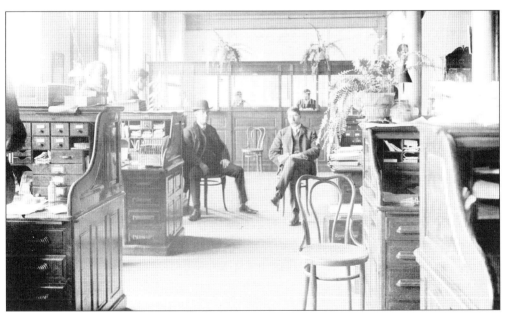

Churchill did business all over Iowa, and kept careful track of all its shipments. These records were kept at rows of roll-top desks in the business office. The company proclaimed that, "everything is up to date from the office appliance to methods of accounting." (Courtesy of The History Center.)

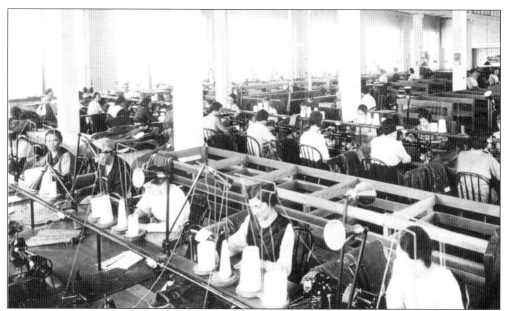

Inside the Evans Garment Co. in 1935, the large sewing room shows the workers at their stations. The factory was located at 301 Sixth Avenue SE and made "Shirley Jean" label housedresses and "Mule Brand" men's work clothes. Employing 50 to 75 men and women, the factory could turn out 50 to 75 dozen housedresses and 100 dozen pieces of work clothing per day. (Courtesy of The History Center.)

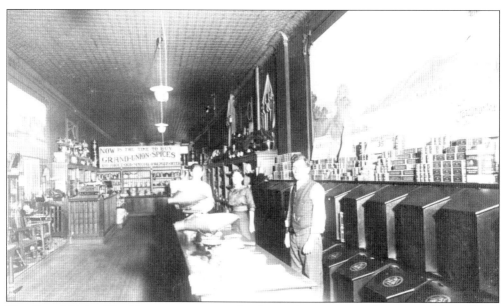

The Grand Union Tea Company was one of a chain of stores across the nation. They offered coffee, tea, baking powder, extracts, and spices. They advertised that they sold pure goods at the lowest cash price and gave premiums for valuable goods. These "valuable goods" are displayed along the left wall and back of the store. The Cedar Rapids store was located at 210 Second Avenue SE. (Courtesy of The History Center.)

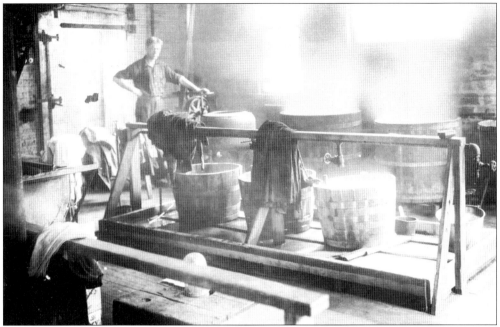

Laundries at the turn of the century were dominated by boiling vats of water, washtubs, and hand wringers. Patrons had to sew labels into or mark all laundry taken to the laundry. One of the prevalent problems for patrons was lost laundry. Also, inexperienced workers could ruin garments. (Courtesy of The History Center.)

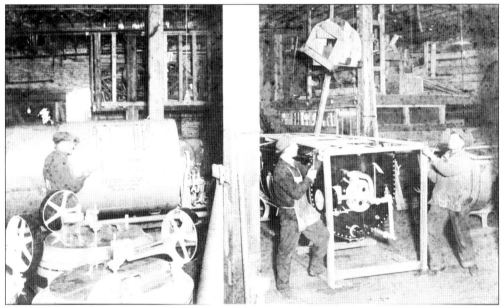

The J.G. Cherry Manufacturing Company, located at Tenth Avenue SE by the Fourth Street railroad tracks, designed and built equipment for dairies, which enabled farmers to store and transport milk by more sanitary methods. In this c. 1910 photo, employees work to crate the Perfection Churn & Worker, which was used to process butter and cheese. (Courtesy of The History Center.)

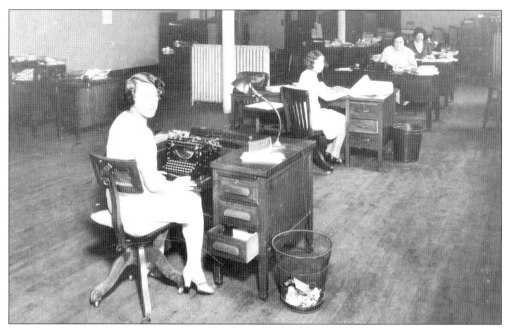

Palmer Business College office workers are at their typewriters and desks in this photo taken in 1932. Martha Dusek, seated at the desk in the front, was a stenographer and a graduate of the college. (Courtesy of The History Center.)

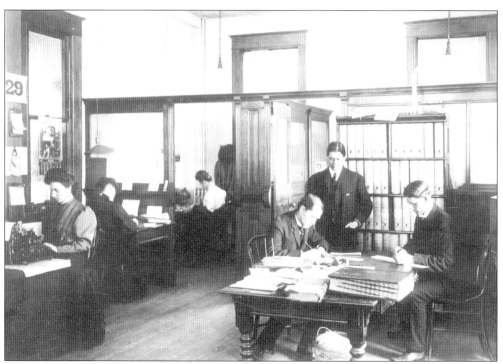

Business offices kept many records by hand, as indicated in this c. 1910 photo. Ledgers marked "Transfer" are lined up on shelves along the wall; the men at the table record handwritten entries, while the woman on the left uses a typewriter. (Courtesy of The History Center.)

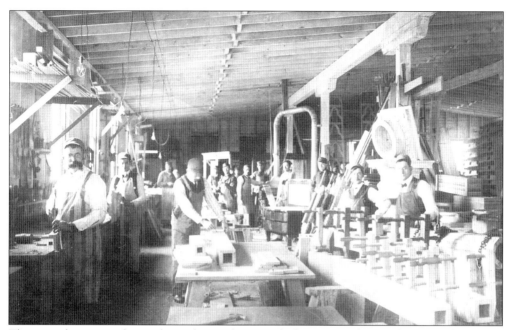

These workers manufactured wooden architectural elements such as columns and capitals. Numerous clamps hold a hollow column on the sawhorses to the right. (Courtesy of The History Center.)

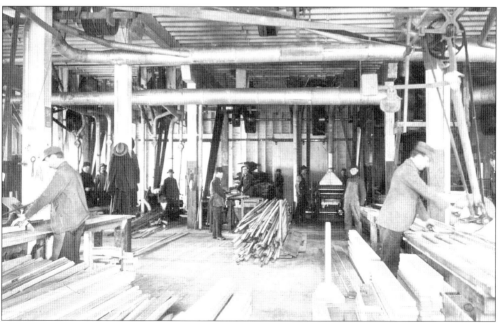

Planing mills produced window and door sashes, doors, interior finishing, and all kinds of woodwork. This photo was probably taken in one of the two planing mills in Cedar Rapids in 1900. The workers are shown cutting the wood to the correct length. (Courtesy of The History Center.)

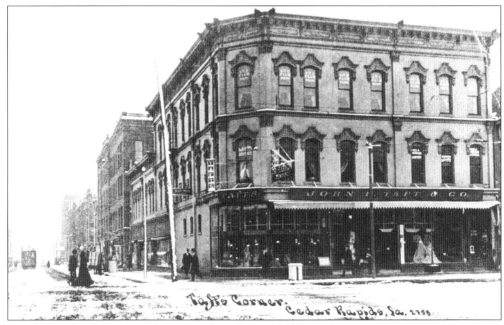

The Killian family came to Cedar Rapids and opened Killian's Department Store in 1911 at the southwest corner of First Avenue SE at the location of the former John H. Taft store. The store offered dry goods, ready-to-wear clothing, home furnishings, draperies, and floor coverings. (Courtesy of George T. Henry.)

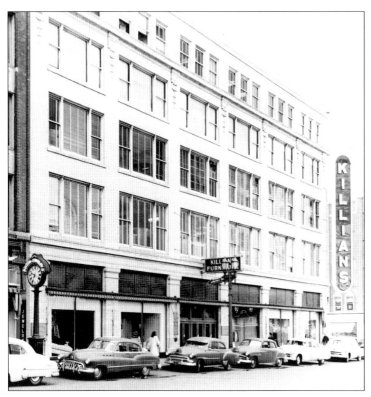

In 1913, Killian's moved to a new location at Third Avenue and Second Street SE, a move considered risky, because it was outside of the business district at that time. Also, the store increased from five departments to 35 and added a tearoom. The move was apparently a success, because the store prospered at that location until it closed in 1982. (Courtesy of George T. Henry.)

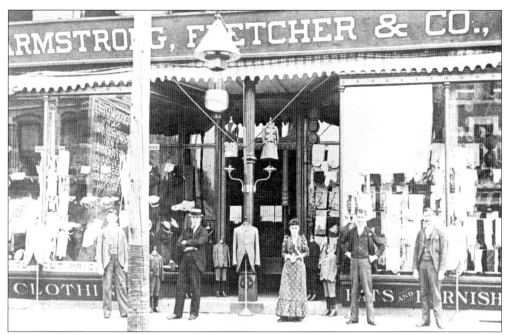

In 1890, Samuel Armstrong, in partnership with James Fletcher, opened a clothing store at 120–24 Second Street SE. Display windows were well used at that time. Shown in front of the store were John Roshek, Bob McClenahan, Ida Boettcher, Ross Free, and James Fletcher. Samuel Armstrong was in Chicago and missed the photograph. (Courtesy of George T. Henry.)

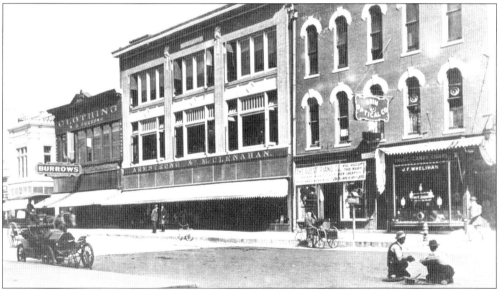

After James Fletcher left the state in 1891, Armstrong became partners with Robert McClenahan, Joe Miller, and Addison Ramsey, and the store was known as Armstrong-McClenahan. The store prospered, using all three floors and the basement of the building. Armstrong-McClenahan established a new pricing policy for a business where bargaining for a price had been the norm. The price was clearly marked on each item for sale, and their motto was "one price to all." (Courtesy of The History Center.)

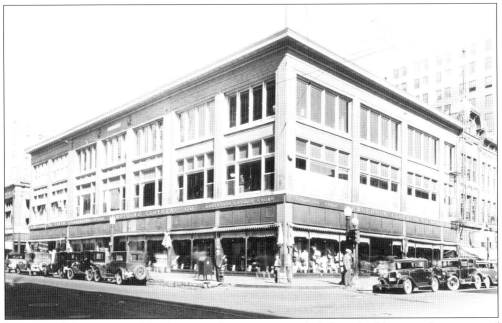

In 1913, the Armstrong-McClenahan Company extended their building to the corner of Second Avenue and had entrances on both Second Avenue and Second Street. This photograph dates to the late 1920s after McClenahan left the Company. (Courtesy of The History Center.)

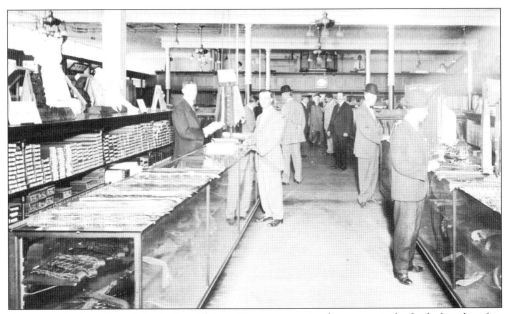

Armstrong's first floor Men's Furnishings Department is shown as it looked shortly after opening in 1913. Samuel Armstrong stands in the rear, fourth from the right. Other owners of the business include Addison Ramsey showing a coat in the back to the left of Armstrong, and Joe Miller behind the counter on the right. (Courtesy of The History Center.)

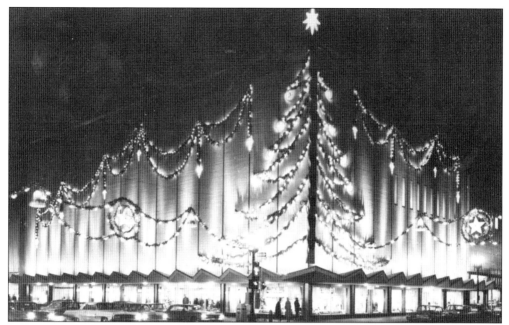

Armstrong's put its best foot forward with this holiday display in 1963. The modern building at Third Avenue and Third Street SE, occupied in 1959, made Armstrong's one of the largest department stores in Iowa. An innovative feature of the building was the "air curtain" doors, which presented no physical barrier to patrons, but maintained temperature control within the store. (Courtesy of George T. Henry.)

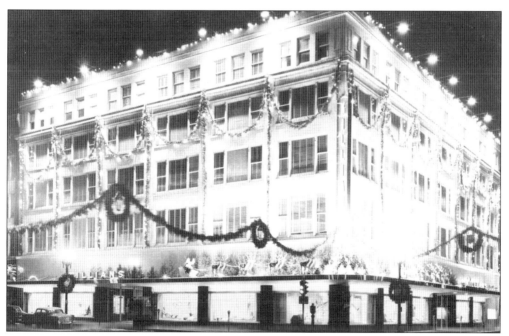

Since only a block separated the two major department stores, the holiday season presented a wonderland for children of the area. Killian's Department Store featured Santa, his sleigh, and the famous reindeer. (Courtesy of George T. Henry.)

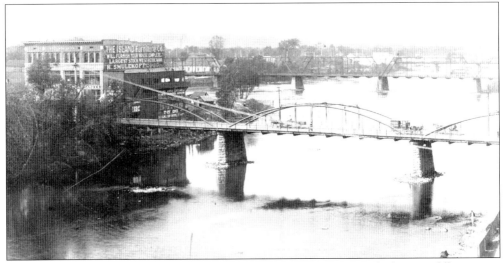

Henry Smulekoff arrived in Cedar Rapids from Russia in 1884. He worked as a peddler to save enough money to buy a furniture store. Soon, he was able to afford a shop on May's Island. Business was so good that he built a bigger "Island Store." By 1910, the city wanted to build on the island, so Smulekoff sold the building, which was used for a time as City Hall. Smulekoff's store then moved to 107–115 Third Avenue West. (Courtesy of The History Center.)

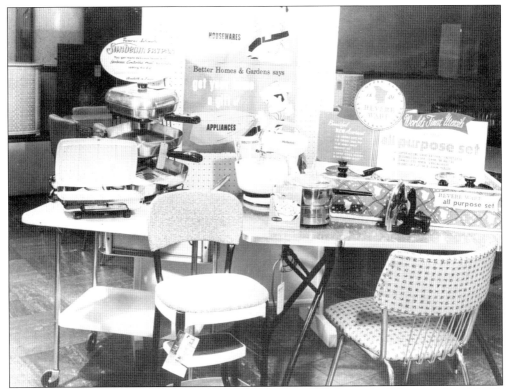

In 1942, Smulekoff's moved to its present location on First Street at Third Avenue. Smulekoff's sold housewares and appliances in addition to furniture, as can be seen in this photo of a 1964 store display. (Courtesy of George T. Henry.)

In 1893, Herman and Josephine Craemer opened a dry goods store at 211 First Avenue SE and lived above the store while they were getting started. Herman Craemer died in 1908, leaving Josephine a widow with two young children. Rather than selling out, she took over management of the store until her son Nicholas was old enough to take over in 1919. The store expanded in 1937, giving the store another entrance on Second Avenue SE. This image shows the First Avenue entrance to Craemer's in 1958. The Neisner Brothers store is next door. (Courtesy of George T. Henry.)

During Carnival Days in 1940, the employees of Neisner Brothers, Inc. pose in their colorful carnival gear and hats in front of the store at 213–215 First Avenue SE. "Five and Dime" stores provided inexpensive merchandise of all kinds. Customers could find most everything they wanted in that one stop. (Courtesy of The History Center.)

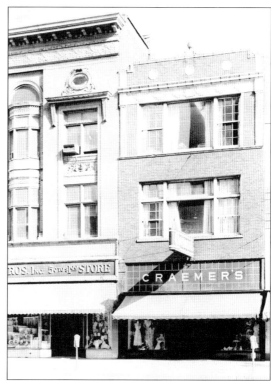

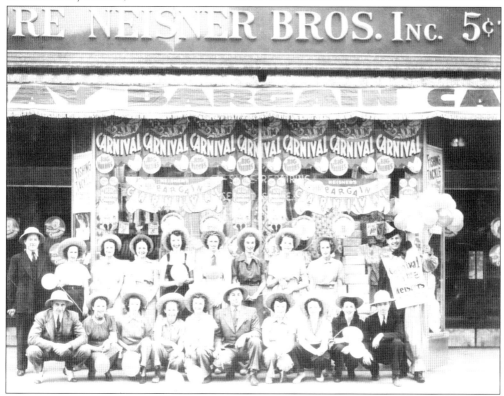

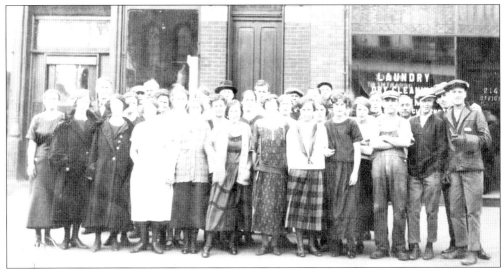

Troy Laundry began their business with wet wash only, largely shirts and collars, but added dry cleaning services in 1925. They also offered mothproof dry cleaning, which was guaranteed for six months. Here, the Troy employees pose in front of the business at 214 First Street SW in 1930. (Courtesy of The History Center.)

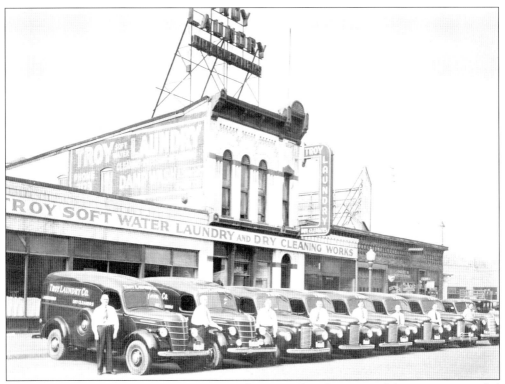

One of the Troy Laundry ads asks "may we call for your bundle?" One of the services provided by laundries was to pick up and deliver to the residence. The Troy fleet of delivery trucks and drivers pose in front of the remodeled and expanded Troy Laundry in 1940. (Courtesy of The History Center.)

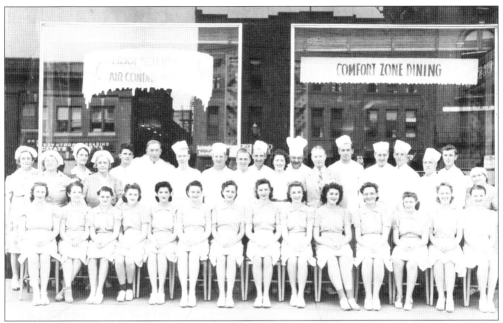

Bishops Cafeteria originated in Waterloo, but its second restaurant opened in Cedar Rapids at 321 First Avenue SE in 1922. Friends who worked downtown would meet every morning to have breakfast together at the cafeteria. Bishop's employees pose in front of their air-conditioned store, about 1940. (Courtesy of The History Center.)

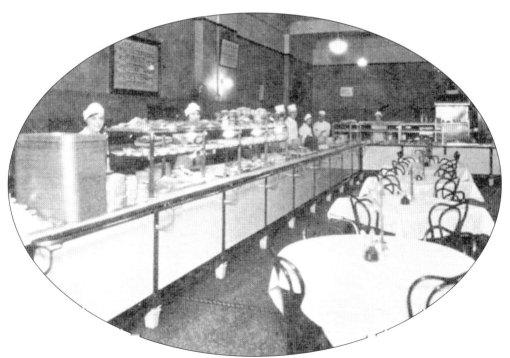

An array of food, crisp table linens, and welcoming staff kept Bishops a popular lunch spot until 1981. (Courtesy of The History Center.)

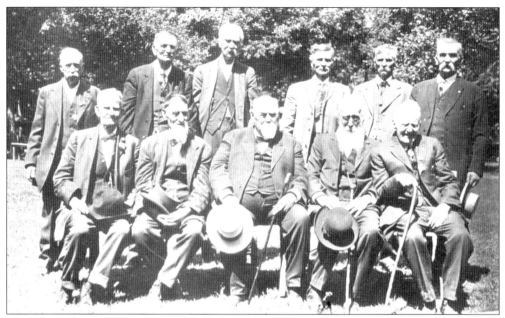

This photo documents a reunion of Civil War veterans in 1905. Linn County resident Josiah Sanborn is seated second from right. He enlisted in Company A of the 31st Iowa Volunteer Infantry in August of 1862. The diary of his experiences in the war with illustrations is housed in The History Center archive. (Courtesy of The History Center.)

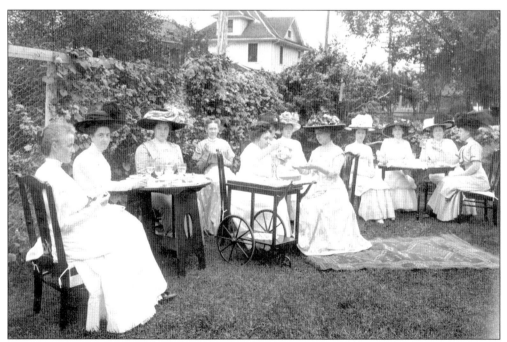

In the early 1900s, tea parties were popular with women. The hostess of this party chose to entertain out on her beautiful lawn. She has even brought the teacart outside. All the ladies present are dressed for tea, and many wear the huge hats popular at the time. (Courtesy of The History Center.)

Four
MILLING AND
HEAVY INDUSTRY

Cedar Rapids industrial centers have always been the key to its progress. After the end of the Civil War, the advent of rail expansion began the transformation from small, local-market businesses to larger industrial companies with regional and national status. Industries soon emerged that would have tremendous impact not only on Cedar Rapids, but also on the state of Iowa. Agricultural industries especially flourished, which mirrored Cedar Rapids' Corn Belt location. These food production industries included the Douglas Starch Works (Penford Products), North Star Oatmeal (Quaker Oats), Sinclair Meatpacking (Wilsons, Farmstead), J.G. Cherry (Cherry Burrell, Evergreen Packaging). At the turn of the 20th century, iron manufacturing industries were founded, and eventually large communications industries as well as a vast supply of workers was needed to staff these rapidly growing industries and a flood of cultural migration followed.

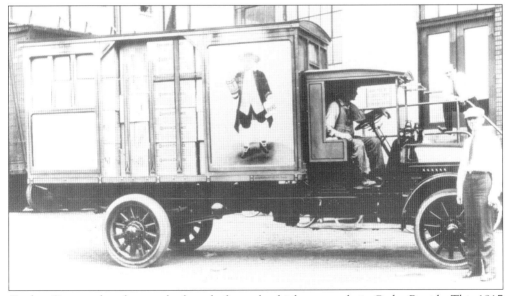

Quaker Oats produced a popular brand of cereal, which was made in Cedar Rapids. This 1917 Quaker Oats delivery truck has the familiar Quaker likeness painted on the side. (Courtesy of The History Center.)

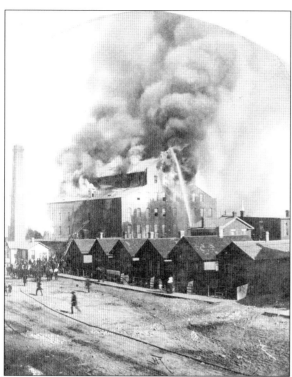

In 1873, Robert Stuart and his father came to Cedar Rapids from Canada and established the North Star Oatmeal Mill at Third Street and C Avenue NE. Henry Higley was a partner for a short time in the steam-powered mill. A longer association was with George B. Douglas and his father, George Sr., which endured many years. The fire shown occurred in 1887. (Courtesy of The History Center.)

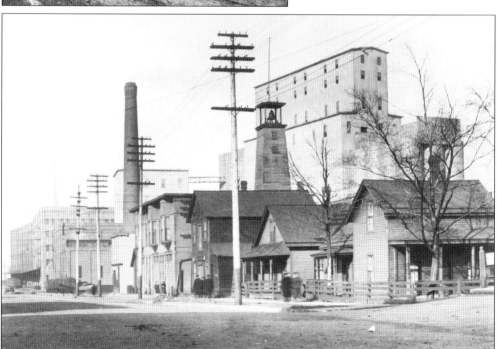

Around 1891, Douglas severed his connection with the North Star Company. In 1901, the American Cereal Company was incorporated as Quaker Oats. In 1905, the company suffered from a fire that consumed four elevators filled with over one million bushels of oats, despite the proximity of the Central Fire Station at 214 N. Third Street. (Courtesy of The History Center.)

After the disastrous fire of 1905, Quaker Oats was rebuilt, constantly increasing in size and capacity of production. In 1927, the packaging building and primary grain storage were constructed. (Courtesy of The History Center.)

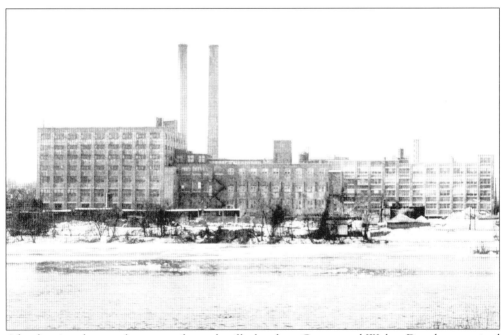

After leaving the conglomerate of cereal mills, brothers George and Walter Douglas organized Douglas & Company for the manufacture of cornstarch in 1903. This soon became the largest starch industry west of the Mississippi River and by 1919, was processing 20,000 bushels of corn a day. (Courtesy of The History Center.)

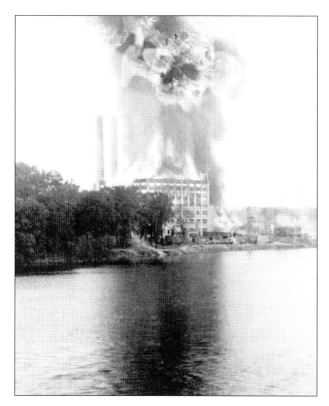

On May 22, 1919, at 6:30 p.m., there was a massive explosion at the Douglas Starch Works plant, which leveled the entire plant and killed 43 persons. The explosion happened after the main shift had gone home for the day; otherwise, many more would have died. (Courtesy of The History Center.)

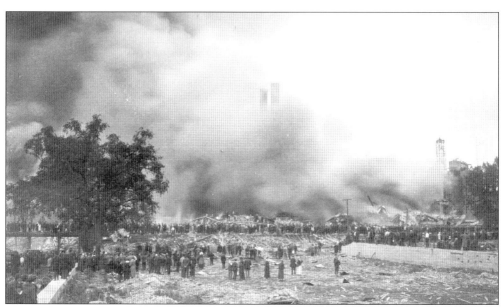

The explosion and resulting fire completely destroyed the Douglas Starch Works. The air was filled with thick clouds of smoke, and the rubble was so hot that it quickly burned through the shoes of the rescuers who flocked to the site. The blast was so strong that it was felt miles away, where people believed it was an earthquake. (Courtesy of The History Center.)

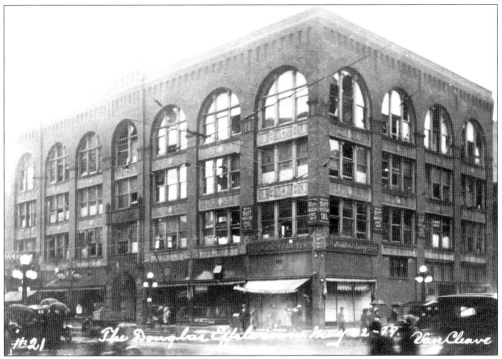

The Douglas Starch Works blast broke at least 175 panes of plate glass in downtown-area windows, including those in the Granby Building. Also broken was the largest plate of glass in the state at Denecke's store. Most of the homes near the plant site were severely damaged or destroyed; many were occupied by Douglas Starch Works employees. (Courtesy of The History Center.)

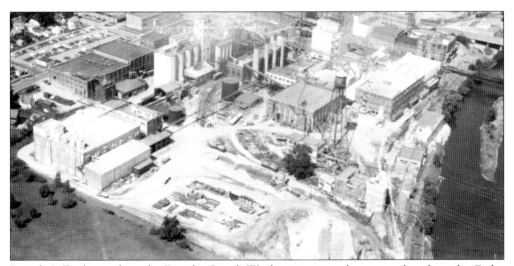

Penick & Ford grew from the Douglas Starch Works ruins into a huge complex along the Cedar River and in 1965 employed about 1,000 people and manufactured a diverse line of products. (Courtesy of The History Center.)

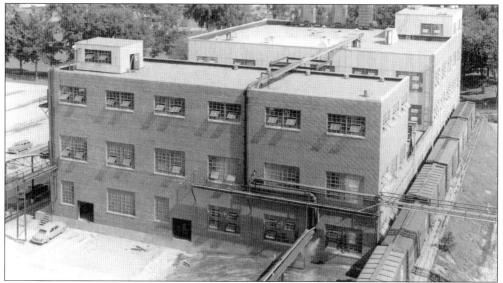

At a Penick & Ford loading area in 1959, railroad cars could be loaded or unloaded directly into the building. The corn processing plant made starch, corn syrup, molasses, and many other related products. (Courtesy of George T. Henry.)

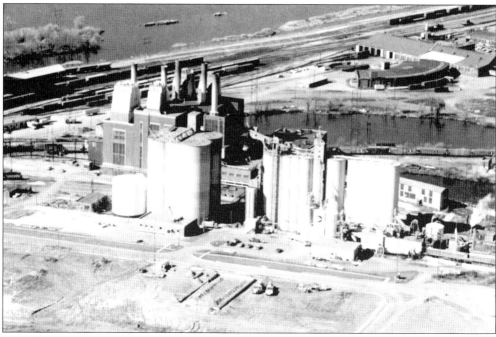

Cargill, Inc. grain processing moved to Cedar Rapids in 1943 with the purchase of a mill at 413 Sixth Street NE. One year later the plant was mostly destroyed in a huge fire. Iowa Milling Company, owned by Joe Sinaiko, bought the burned plant and rebuilt it for soybean processing. In 1968, Cargill again purchased the plant. In addition to this plant, Cargill opened two other grain processing plants and an analytical laboratory in Cedar Rapids. The company produces livestock feeds, corn syrups, starches, and oils. (Courtesy of The History Center.)

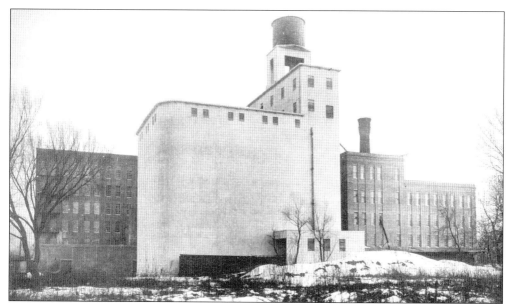

Corno Mills was founded in East St. Louis, Illinois. In 1910, the company purchased Pawnee Mills, located at 1515 H Avenue NE in Cedar Rapids and became National Oats. The company produced rolled oats and invented a new process making it possible for the consumer to cook oatmeal in only 3 minutes rather than the previous 20 minutes, naming the resulting product 3-Minute Oats. The company also produced grits, cornmeal, popcorn, and Dura Bukets, which are plastic buckets for factory use. (Courtesy of The History Center.)

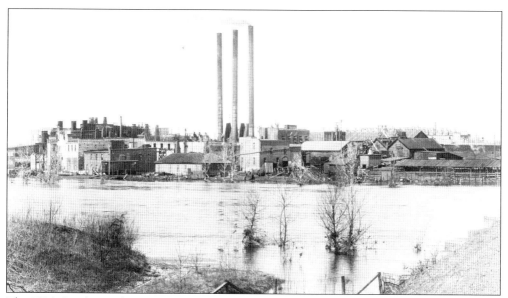

The T.M. Sinclair and Company Packing Plant was established in 1871 by T.M. Sinclair in an icehouse on the east bank of the Cedar River. The packing plant was built in 1872 at the south end of Third Street SE. Sinclair produced several brands of meat products including Fidelity smoked hams and bacon, Magnolia and Sinclair brands of lard, and Red Cross vinegar-pickled meats. This photo was taken about 1900 from the west bank of the Cedar River. (Courtesy of The History Center.)

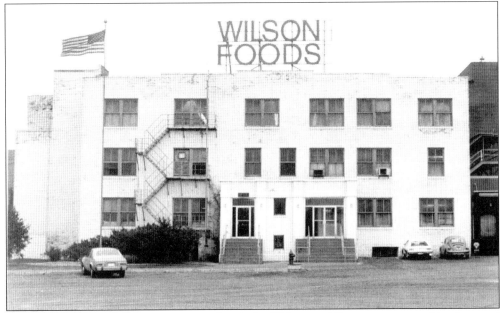

The Sinclair Company became associated with the Wilson and Company meatpacking house of Chicago in the early 1900s. In the 1930s, Wilson took over operating control, and by 1935 was producing under the name of Wilson and Company. The plant continued operation under that name until 1984 when it was sold to Farmstead Foods. The plant was closed in 1990, ending the reign of meatpacking as a primary Cedar Rapids industry. (Courtesy of The History Center.)

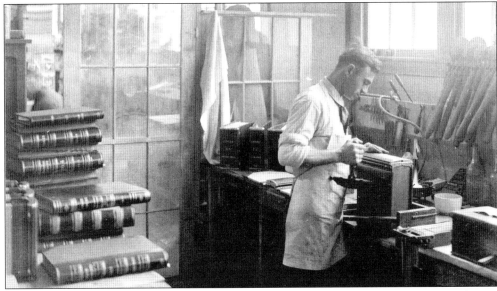

LeFebure Ledger Company was established in 1892 by Emile LeFebure and became the largest producer of ledgers and bank books in the state of Iowa. Their specialty was the "X-Ray Ledger," a self-indexing ledger with lettered tabs. The company added office equipment and ultimately banking and security equipment to their product line. This 1917 image of the Finishing Department was where the name of the customer's firm was embossed on the cover. (Courtesy of The History Center.)

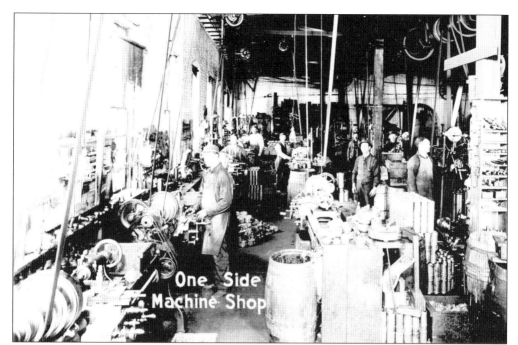

The Chandler Pump Company moved to 804 First Avenue NW in Cedar Rapids in 1890 to manufacture wood and iron pumps, radiators, windmills, tanks, and plumbing supplies. With the addition of furnaces and boilers to the product line in 1931, the company name was changed to Chandler Company. This photo of the Chandler machine shop floor shows the manufacture of plumbing fittings during the early 1900s. (Courtesy of The History Center.)

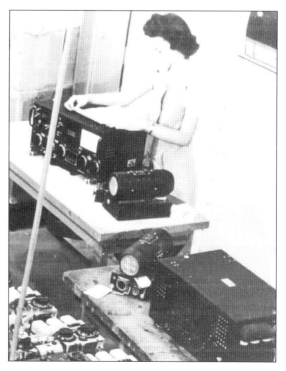

Collins Radio Company components await placement in their housing in this 1940s factory photo. The Collins Radio Company was founded by Arthur Collins, who built his first radio when he was nine years old and grew up to revolutionize the radio industry. Collins transmitters were used on Admiral Byrd's second Antarctic expedition. Collins entered avionics with the development of the Autotune® airplane transmitter tuning device. Collins explored all avenues of communication, including space flight communication and computers. (Courtesy of Rockwell Collins.)

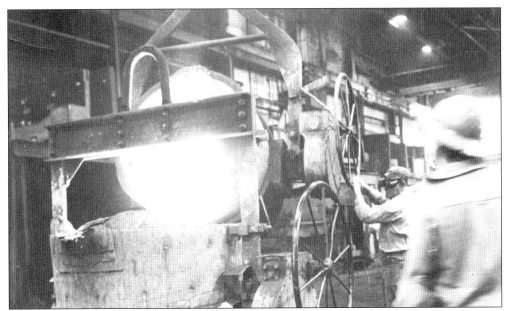

The Iowa Iron and Steel Company developed from the Whiting Brothers foundry established in 1881 (later Carmody Foundry and Machine Company). It was purchased by industrialist Howard Hall in 1918 and run as a sister company to large machinery manufacturer, Iowa Manufacturing. Iowa Iron and Steel produced machine tool bases, crane counterweights, bank vault doors, and other castings. This *c.* 1960 image shows molten iron castings being poured. (Courtesy of The History Center.)

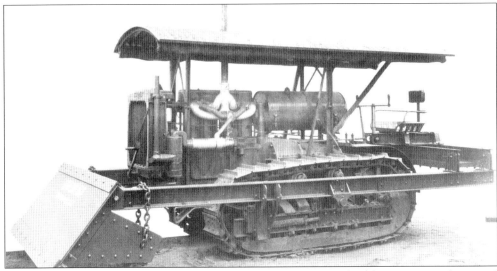

Ed LaPlant of Cedar Rapids had a national reputation for moving buildings. In 1911, he joined with engineer Roy Choate to manufacture house-moving equipment. After first operating out of a barn, a factory was constructed on First Avenue East to house the growing business. The company expanded to manufacture heavy earth-moving machinery. In 1923, it began manufacturing a hand-operated tractor blade to push material ahead of a tractor. The first model completed is pictured and was sold for use on the Dixie Highway in Kentucky. The company was bought by Allis-Chalmers in 1952. (Courtesy of The History Center.)

Five

SCHOOLS, LIBRARIES, RELIGIOUS INSTITUTIONS, AND HOSPITALS

By the turn of the 20th century, Cedar Rapids had two major hospitals, Mercy and St. Luke's, the nationally renowned Coe College, and impressive school buildings throughout the downtown and residential areas. A visitor on the train through downtown Cedar Rapids could look out to the edges of Greene Square Park to see the beautiful Cedar Rapids Library, Washington High School, and "Church Row."

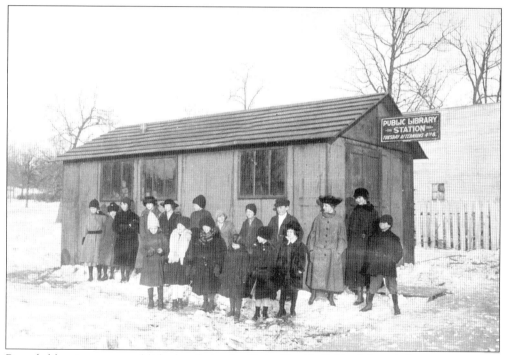

Branch libraries were established early in the Cedar Rapids Public Library's history to provide greater access to more readers and the branches were very popular with patrons. This 1920s image shows the Daniels Park branch library at 1358 H Avenue and a group of young readers. (Courtesy of The History Center.)

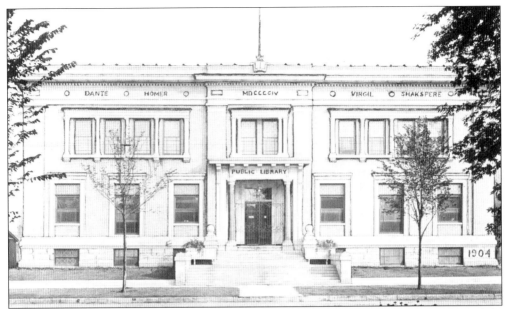

The Cedar Rapids Public Library was built in 1904 with the aid of funds donated by philanthropist Andrew Carnegie. At this time, women were only allowed to vote on local issues; and it was the women, led by prominent Cedar Rapidian Ada VanVechten who successfully campaigned for a new library. The library was located in this building until 1985 when a new library was opened on First Street SE. The Carnegie building was incorporated into the Cedar Rapids Museum of Art. (Courtesy of The History Center.)

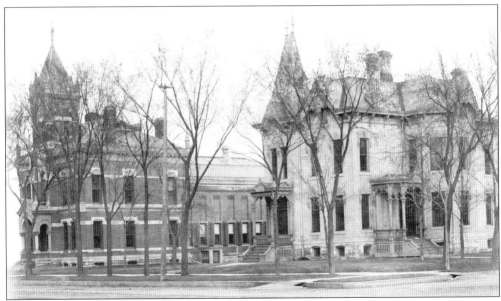

The Masonic Library was established in 1844 by T.S. Parvin, secretary to territorial governor Robert Lucas. The library collection moved several times with Parvin until finally settling in Cedar Rapids. The old Masonic Library (left) was built in 1884 at 817 First Avenue SE with books on many subjects and was open to all. The residence to the right eventually became the library annex. A new building was constructed on the site in 1955. (Courtesy of The History Center.)

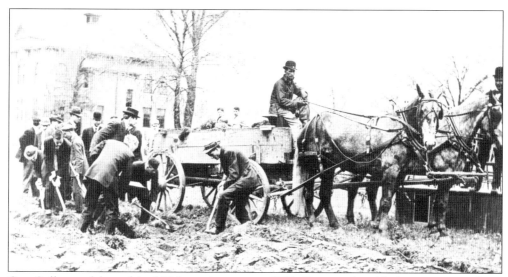

Coe College celebrated its 150th anniversary in 2001. From its humble beginnings, with 18 students crowding into the parlor of Williston Jones, the school got its start in 1851. Here, students load the first wagon of dirt from the groundbreaking of Sinclair Chapel in 1910. (Courtesy of Coe College.)

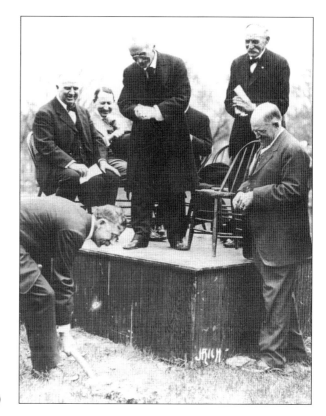

The groundbreaking for Science Hall was funded by the Carnegie Foundation in 1909. Clifton Bates of the chemistry department holds the shovel. On the platform are A.T. Averill, Samuel Armstrong, Dr. E.R. Burkhalter (standing, hands clasped), J.T. Liddle, and to the right of the platform, Dr. Kegley. (Courtesy of Coe College.)

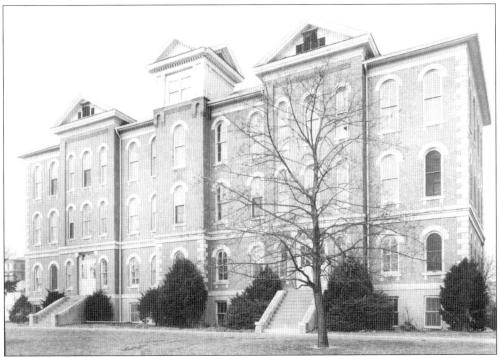

Old Main, with the first half of the building being erected in 1868 and the second half added in 1884, was the first building on the Coe campus. It was torn down in 1972 to make way for the Dows Fine Arts Building. This photo shows Old Main as it appeared about 1948. (Courtesy of George T. Henry.)

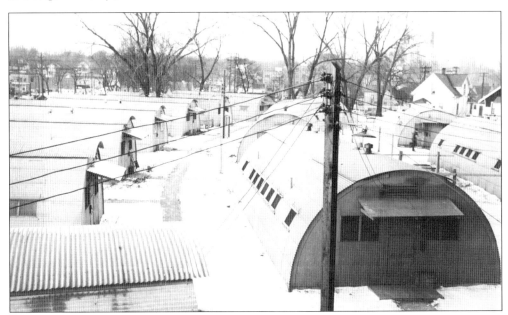

Increased enrollment as a result of the GI Bill following World War II prompted Coe College to erect Quonset Huts for on-campus living, as seen in this photograph taken about 1948. Married students were some of those who found rooms here. (Courtesy of George T. Henry.)

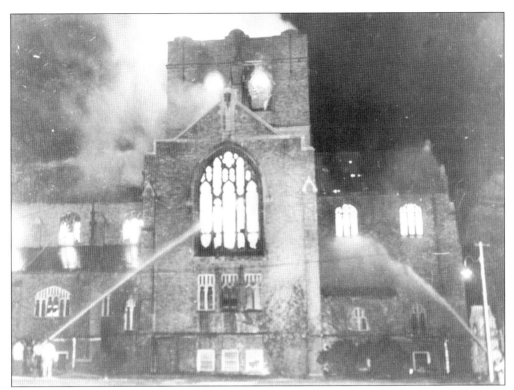

In 1947, the Sinclair Chapel on the Coe campus burned. Only the walls of this once-beautiful structure remained. The chapel had been a gift from the Sinclair family of the Sinclair Meat Packing plant. (Courtesy of George T. Henry.)

After the fire, Coe President Hollenshead and Charles W. Stevens Jr. '49, with his friend, "Gabby Valentine," surveyed the damage from inside. (Courtesy of George T. Henry.)

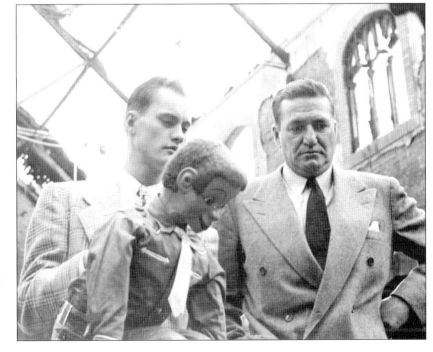

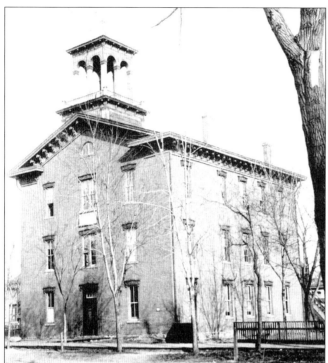

The original Washington School was built in 1855, on the corner of Fourth Avenue and Fifth Street SE. It initially served both grade school and high school students but was later converted to a high school. The three-story building was heated by wood stoves and was at the time the largest public school in the state. (Courtesy of The History Center.)

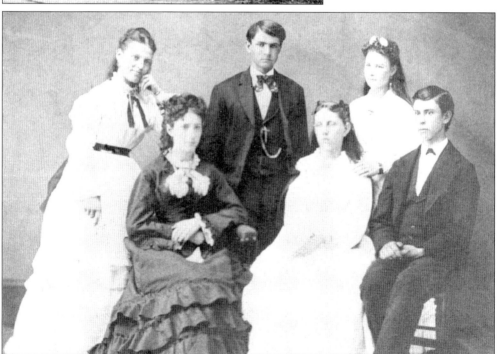

Washington had its first graduating class in 1873. Graduates from this first class are shown. Pictured, from left to right, are the following: (front row) Mollie McClenahan, Julie Sargent, and Gordon Murray; (back row) Eva Stiles, John Leonard, and Harriet Boyce. (Courtesy of The History Center.)

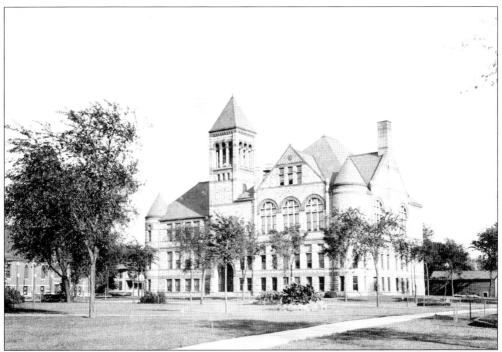

In 1890, Cedar Rapids citizens voted to approve a bond issue to erect a new Washington High School building, which was completed in 1892. The building was located on the south side of Greene Square Park. It was constructed from local limestone. In 1906, the enrollment had risen to 720 students. (Courtesy of The History Center.)

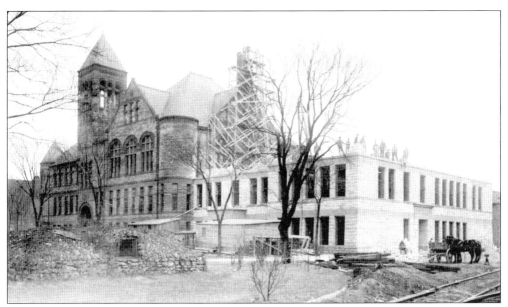

In 1910, an addition was added to Washington High School. Notice how close the school was to the railroad tracks. Students who attended classes there told stories of how the building shook when trains passed on the nearby tracks. The high school remained at this location until it was torn down in the late 1940s. (Courtesy of The History Center.)

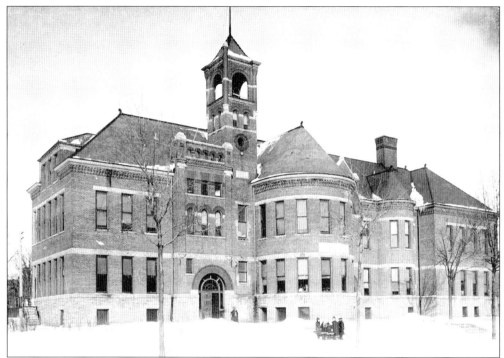

One of the early elementary schools was Polk, constructed at 15th Street and B Avenue NE in 1893. This was the second Polk School building and has since been replaced by a third Polk School building. This building was described in the *Cedar Rapids Gazette* as possessing a tower rising to the height of 80 feet, entirely composed of brick. (Courtesy of The History Center.)

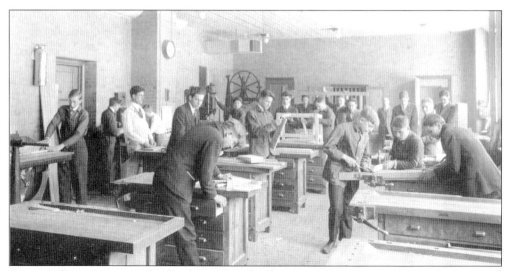

In 1915, Grant Vocational School was completed at 346 Second Avenue SW. It was a real trade school with courses in shop practice, mechanical drawing, woodworking, sheet metal work, electrical work, laundry, machine shop, pattern making, foundry, auto mechanics, printing, cooking, sewing, and household arts. In 1924, the school adopted a regular curriculum. The last class graduated in 1935. This 1916 photo shows the woodworking shop. (Courtesy of The History Center.)

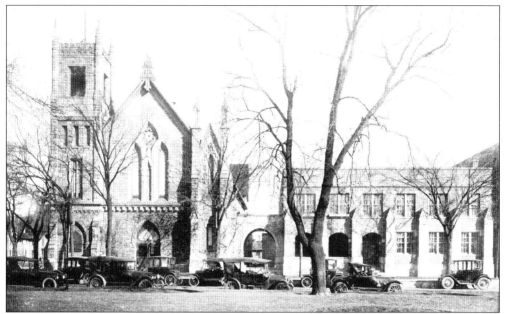

The First Presbyterian Church at Third Avenue and Fifth Street SE was completed in 1869 and is the oldest intact church building still in use in Cedar Rapids today. During construction, a strong wind blew off part of the roof. The church bell was a gift from Mrs. John Ely. The Resurrection art glass window, designed by Tiffany, was donated by Mrs. Sinclair in memory of missionaries killed in the Boxer Rebellion. This photograph of the church was taken around 1928. (Courtesy of The History Center.)

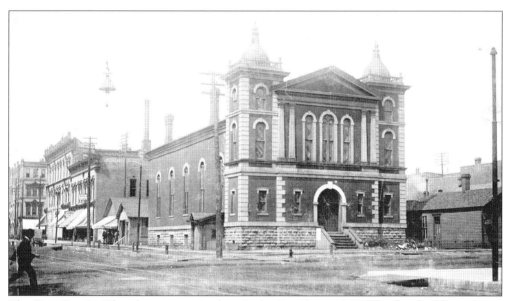

The First Baptist Church was organized in Cedar Rapids in 1860. The first building, shown here, was completed in 1868 at Second Avenue and Third Street SE. In 1893, a new larger building was erected at Third Avenue and Eighth Street. That building was in use until 1917, when a disastrous fire destroyed it. (Courtesy of The History Center.)

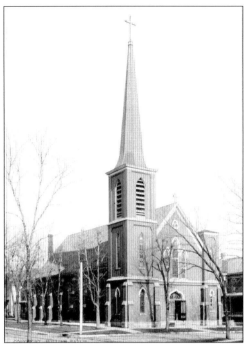

The first documented Catholic Mass was celebrated in Cedar Rapids in 1857. The following year, a small frame church was erected and named Immaculate Conception. Because of the growing congregation, a new church able to seat 600 was completed in 1870 at Seventh Street and Third Avenue, directly opposite the original frame building. A steeple was added at a later date as shown in this *c.* 1900 photograph. The Immaculate Conception structure shown here was replaced by the present church in 1915. (Courtesy of The History Center.)

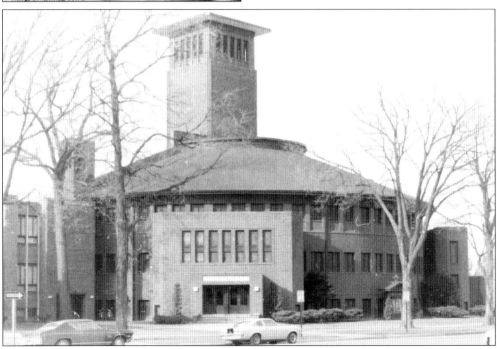

An early congregation organized in Cedar Rapids was St. Paul's Methodist Episcopal, which began meeting in 1841. The present St. Paul's Methodist church, built at Third Avenue and 14th Street SE in 1915, was designed by famed early-20th century American architect Louis Sullivan. Work on the designs was completed by one of the architect's former partners, which resulted in a Sullivan building without Sullivan ornamentation. (Courtesy of The History Center.)

St. Wenceslaus parish was started by a group of Immaculate Conception members who wanted a church to serve the needs of the Czech community. The St. Wenceslaus Church building, located in the 1200 block of Fifth Street SE, was completed in 1875. The schoolhouse, shown in this photo, was built next to the church in 1894, but was eventually demolished in 1988. (Courtesy of The History Center.)

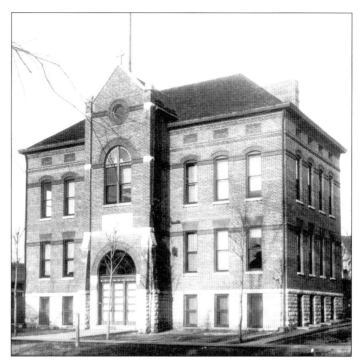

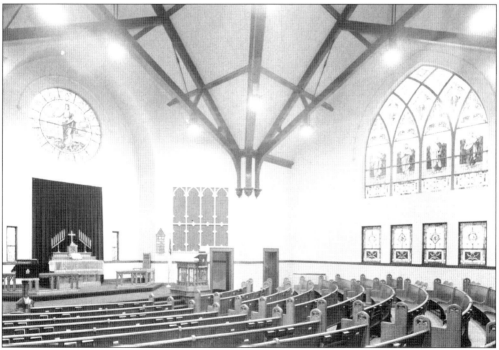

The Lutheran congregation began meeting in 1856 in private homes and later the YMCA. The present First Lutheran Church, located at Third Avenue and Tenth Street was dedicated in 1911 and is the third building to house the congregation. The sanctuary features beautiful stained glass windows. An early live telecast of a Cedar Rapids church service was from First Lutheran on Easter Sunday of 1957, carried by KCRG. (Courtesy of The History Center.)

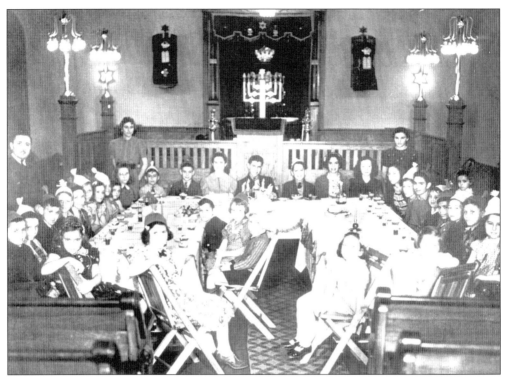

The first synagogue in Cedar Rapids, Beth Jacob, was founded in 1906 by 37 families. A former chapel on A Avenue NW was converted into an Orthodox house of worship. In the 1920s, liberal members organized a Reform congregation, Temple Judah. The two congregations merged and the present Temple Judah houses both sanctuaries. The photo shows the Seder being celebrated at Beth Jacob in the 1930s. (Courtesy of Temple Judah.)

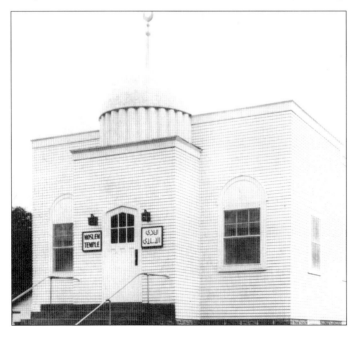

During the early 1920s, a few Muslim men in Cedar Rapids gathered together to pray, calling themselves "The Rose of Fraternity Lodge." As their numbers grew, they built a Mosque at 1335 Ninth Street NW, which was completed in 1934. This building has been called the Mother Mosque of North America because it was the first mosque designed for exclusive use as a mosque and is still standing. The building now serves as an Islamic cultural center. (Courtesy of Islamic Center of Cedar Rapids.)

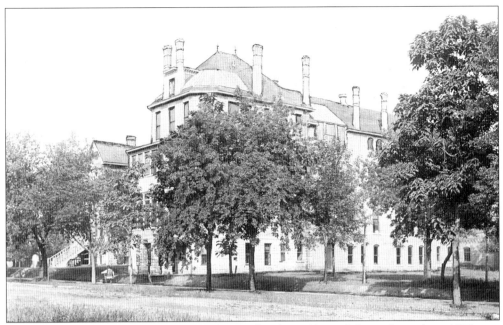

The main building of St. Luke's Hospital, completed in 1884 and shown here about 1895, was built on ten lots donated by Judge Greene's widow and Sampson C. Bever. Control of the hospital was placed in the hands of the Grace Episcopal Church, which retained control until 1923. At that time, a transfer was made to the Methodist Episcopal Church and the hospital became St. Luke's Methodist Hospital. (Courtesy of The History Center.)

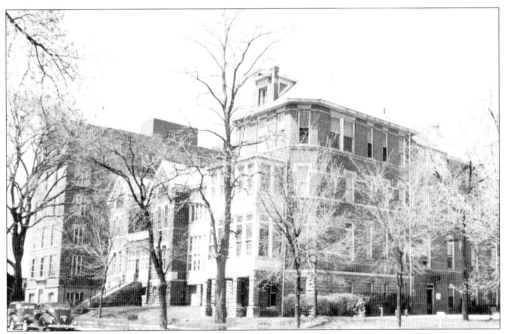

A nurses' residence was added to the St. Luke's hospital complex in 1917, and a west wing was added to the main building in 1926. This 1940 photograph shows both of these additions. (Courtesy of The History Center.)

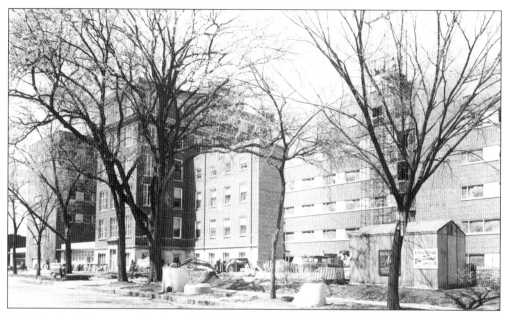

In 1954, the oldest part of the St Luke's complex (1884) was torn down, in addition to the 1902 wing and the antiquated physical plant. A new wing was completed in 1960. (Courtesy of George T. Henry.)

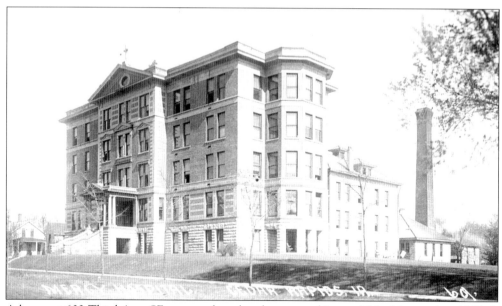

A house at 603 Third Ave. SE was purchased and converted into a 15-bed hospital in 1900. It soon proved to be too small, and the Sisters of Mercy acquired 12 lots in 1901, and in 1903 built Mercy Hospital where it stands today. This photo of Mercy Hospital was taken about 1905, when the main entrance was on the second floor. (Courtesy of The History Center.)

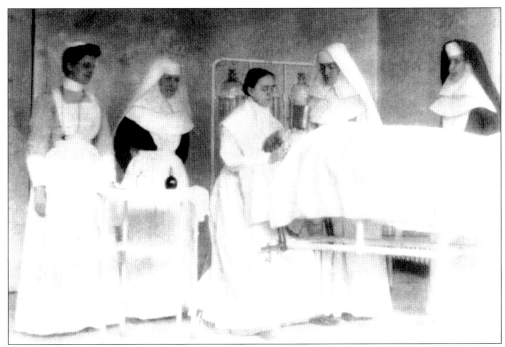

This photo is of Mercy Hospital's operating room in 1903. The patient is attended by Sister nurses and nurses. The operating room was up-to-date for its era. (Courtesy of Mercy Hospital.)

In early days, hospital rooms were almost indistinguishable from residential bedrooms. This photo from the early 1900s shows a single patient room with a chair and a wooden dresser. The floor is covered with a carpet and the windows even have lace curtains. (Courtesy of The History Center.)

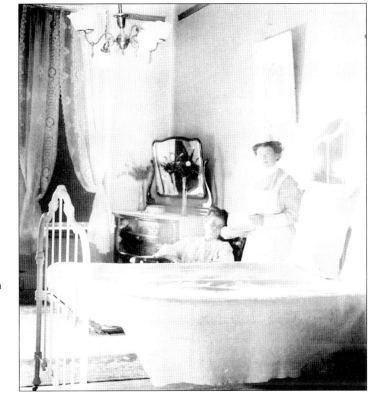

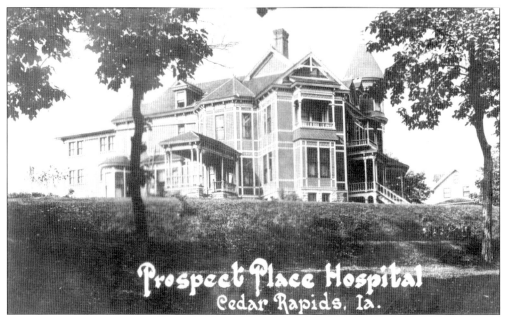

Prospect Place Hospital, 824 16th Avenue SW, began as a 24-room mansion built for the James Young family in the 1880s. It was purchased by Dr. Margaret Sherlock, who opened it as a private hospital, but her endeavor failed. In 1939, the building was offered to the Sisters of Mercy to be used as a convalescent home. Unfortunately, the structure was so unsound that the Sisters were never able to use it, and it was eventually demolished. (Courtesy of The History Center.)

In 1901, Dr. Solon Langworthy brought a new form of healing, chiropractic, to Cedar Rapids. Chiropractic, in which all ailments are treated with manipulations of the bones to relieve pressure on the nerves, was taught at Langworthy's American School of Chiropractic and Nature Cure. He also founded the Health Home. In 1909, the Health Home and the school moved into a large mansion at 500 First Avenue NE, formerly the residence of Walter Douglas. The hospital remained at this location for three years and then moved further up First Avenue. (Courtesy of The History Center.)

Six

MUNICIPAL AMENITIES

As cities grow, citizens expect certain amenities to be provided: pure water for drinking, public safety, and a legal system among others. Out of these needs grow police departments, fire departments, sewage and water treatment plants, courthouses, and a city hall to house the offices of the overseers. Cedar Rapids has a commission form of government housed in a city hall on May's Island in the middle of the Cedar River.

The seven-story Cedar Rapids City Hall on May's Island was completed in 1927 to serve as a memorial to local veterans of World War I. On top of the building is an observation tower in the form of a Greek colonnaded temple, above which rises a symbolic sarcophagus. The huge art glass window, designed by Grant Wood, depicts the Lady of Peace and Victory watching over fighters from all six wars in which the United States had been involved. (Courtesy of The History Center.)

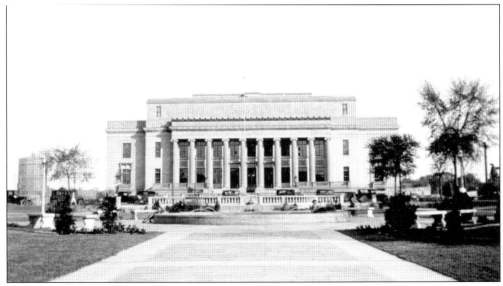

The Linn County Courthouse opened on May's Island in 1925. It is the county's fourth courthouse since 1840, but the only one in Cedar Rapids. Marion was home to the first three courthouses until 1919 when citizens voted to move the county seat to Cedar Rapids. (Courtesy of The History Center.)

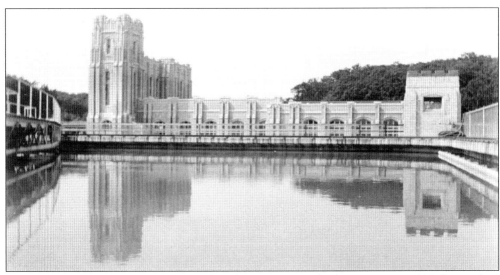

The Cedar Rapids Water Purification Plant began treating drinking water in 1929. Located on J Avenue NE, the facility is an example of Gothic architecture. The plant expanded with increased water demand and stricter water quality regulations. (Courtesy of The History Center.)

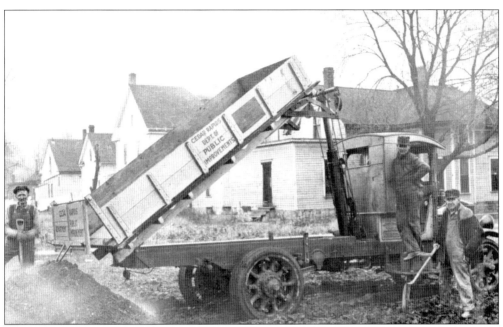

One of the Public Improvements Department tasks was to modernize city streets. This early dump truck relieved city workers from some of the backbreaking labor involved with moving earth and stone. (Courtesy of The History Center.)

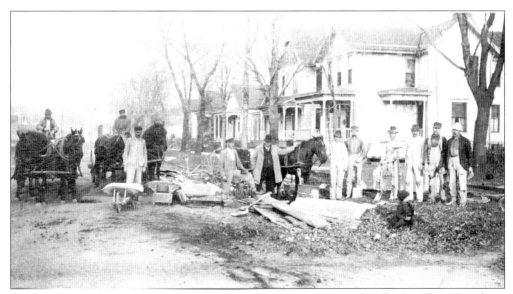

Workers undertake street improvements in the southwest section of Cedar Rapids in this photo taken about 1904. Paving streets, laying storm and sanitary sewers, and installing curbs and gutters were sometimes completed simultaneously to save money and to spare residents inconvenience. (Courtesy of The History Center.)

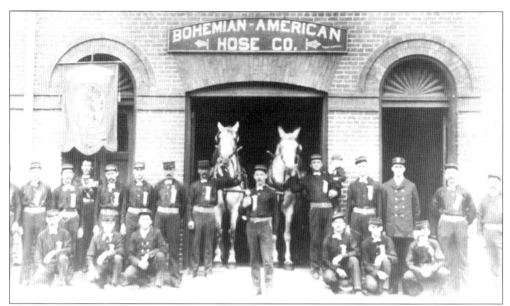

The Bohemian American Hose Company, with 29 volunteer members, was formed and housed at what is now the rear of the CSPS hall on 11th Avenue, between Second and Third Streets. It continued until the advent of the paid fire department in 1894. (Courtesy of The History Center.)

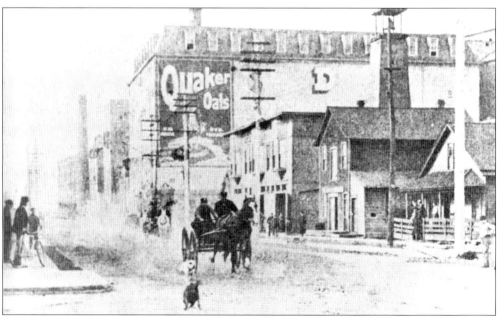

The Cedar Rapids horse-drawn fire engine rushes past the old Central Fire Station at 214 Third Street NE, which was constructed in 1899. In the background is the Quaker Oats plant, built in the late 1880s. (Courtesy of The History Center.)

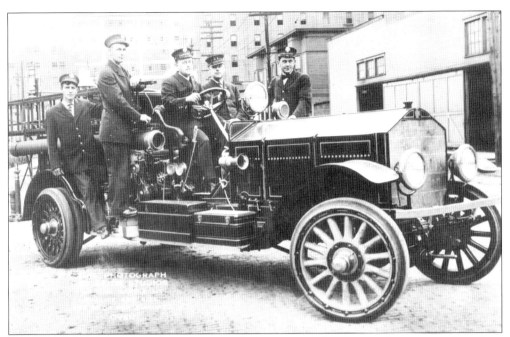

This photo shows one of the two original American LaFrance gasoline powered engines purchased by the fire department in 1914. By 1918, the city had completely motorized, abandoning the horse-drawn carts of the past. (Courtesy of The History Center.)

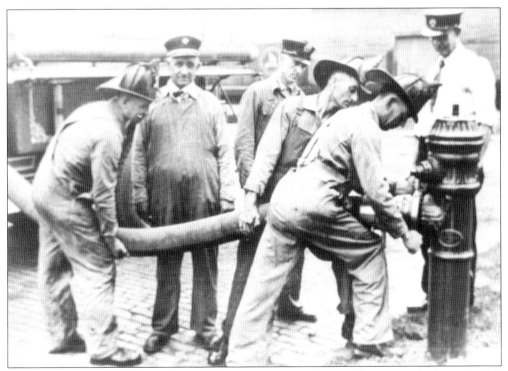

Fire Chief Paul Dolan, at right, and his crew are attaching a hose to a hydrant in this photograph taken about 1930. (Courtesy of The History Center.)

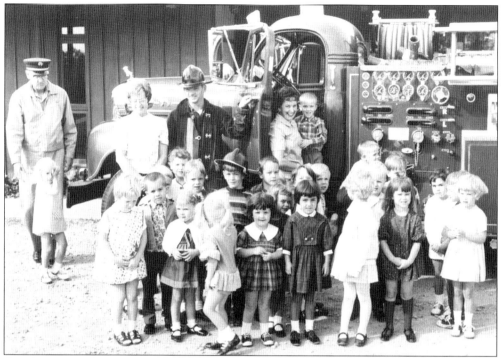

An elementary class visits with firefighter DeWayne Cosgrove and retired firefighter Joseph Tefer. They are standing in front of a 1957 Mack B Model 1000 GPM Pumper. (Courtesy of The History Center.)

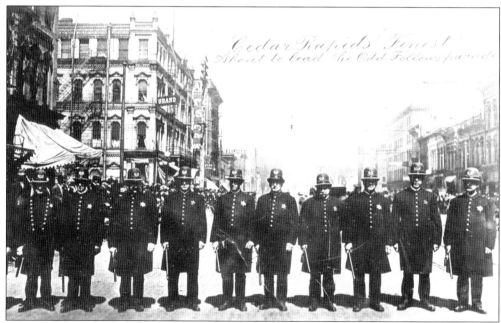

This *c.* 1900 photograph was taken on First Avenue East, looking past the Grand and Delavan Hotels. The officers were dressed in their best uniforms, complete with helmets and nightsticks to lead the Odd Fellows parade. (Courtesy of The History Center.)

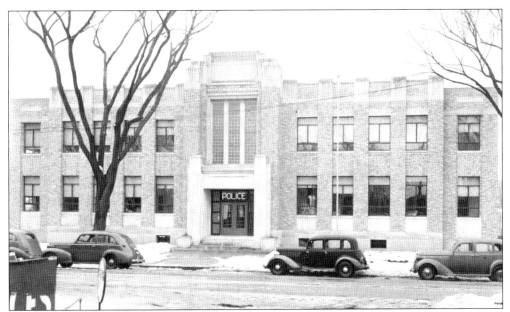

This Police Department Building was completed in 1937. Note the neon sign, "Police" which reflects against the glass front doors. The Art Deco-style building was constructed at a cost of $137,554. It housed a police force of 60, and included a courtroom, and an "escape-proof" jail. This building served as the Central Police Station until 1997, when the present building was built. (Courtesy of The History Center.)

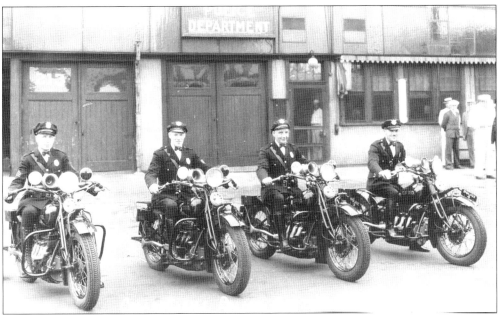

This photograph, taken on July 15, 1934, shows four motorcycle patrolmen in front of the then-police station at 213 First Street SW. George Clifford, who owned the Indian Motor dealership in Cedar Rapids, bid competitively to supply the city with the motorcycles and then taught the officers how to ride them. At the time, motorcycles could go much faster than automobiles and were considered very desirable in police work. (Courtesy of The History Center.)

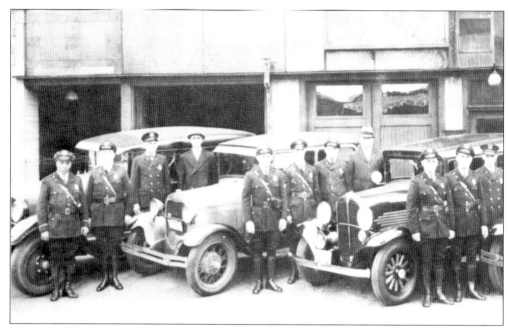

Members of the force pose with their police cars in front of the department building in 1930. The first officer on the left is Virgil Powell, a prominent African-American police officer in the city. Virgil Powell was multi-talented. He developed a new method of fingerprinting, wrote music, and authored and published books. (Courtesy of The History Center.)

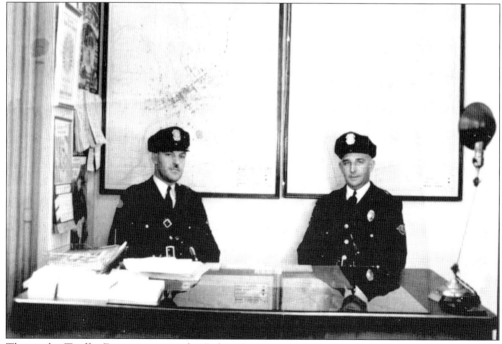

This is the Traffic Department in the Police Station in 1940. On the wall are two maps of the city, plotting the location of traffic accidents for the current and previous years. Trouble spots in traffic flow could be discovered in this manner. (Courtesy of The History Center.)

Seven

BUSINESS AND
RETAIL TRADE

For the first part of the 20th century, Cedar Rapids was known throughout Eastern Iowa for its business and retail trade. These businesses included large retail centers and small specialty shops, from dance halls, restaurants, and theaters, to automobile sales centers and filling stations.

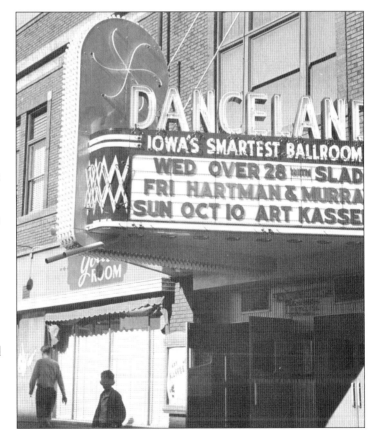

Danceland was located above a bowling alley on Third Street and A Avenue NE and opened in 1927. Big name bands like Glenn Miller, Count Basie, and Louie Armstrong were regulars. Rock and roll bands appeared in the 1950s and '60s and helped popularize this type of music over Eastern Iowa. Danceland was torn down in 1973 to make room for the Five Seasons Center. (Courtesy of The History Center.)

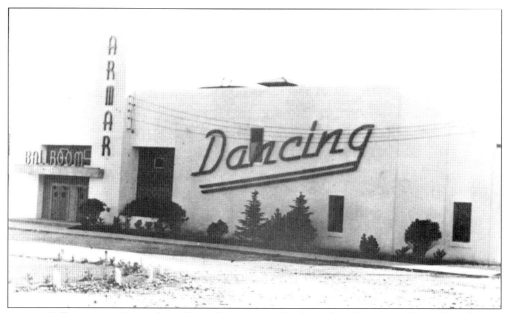

Armar Ballroom was located on First Avenue on the boundary between Cedar Rapids and Marion. It opened Sept. 24, 1948, with the Harry James Orchestra. The admission charged was $2. Big name bands such as Woody Herman, Sammy Kaye, Artie Shaw, Lawrence Welk, Stan Kenton, and many others were featured. Local bands such as Kenny Hofer, Leo Greco and his Pioneers, Joey Paridiso, and others kept the dancers busy. (Courtesy of The History Center.)

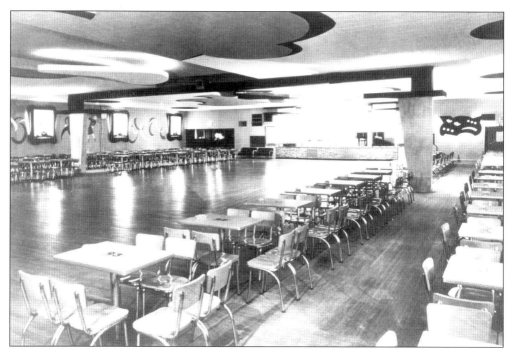

Armar could accommodate 2,800 people on a 68x128-foot dance floor. After 10:30 p.m., local radio stations KCRG and KCRK would carry live broadcasts of the entertainment. The ballroom closed in 1977, and was torn down soon after. (Courtesy of The History Center.)

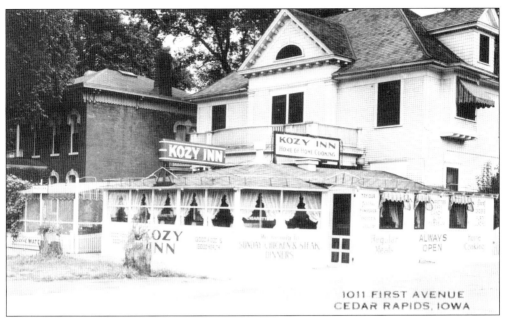

The original Kozy Inn, shown here, started in 1929 as an open-air fruit stand in front of Chuck and Myrt Stickney's house at 1011 First Avenue SE. Later, a pre-built structure replaced this and began to serve sodas, ice cream, and sandwiches, and finally became a full-fledged restaurant. Due to its popularity, Kozy Inn 2 was opened across First Avenue in the fall of 1935. Kozy Inn 1 closed in the 1940s, but Kozy Inn 2 remained until 1999. (Courtesy of The History Center.)

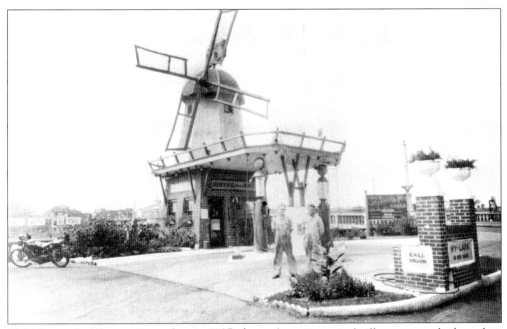

This photo of a filling station, taken in 1927, shows the unique windmill structure, which made it distinctive. It was located on First Street NE on the corner of B Avenue at the entrance to the F Avenue Bridge, so called since it connected to F Avenue NW on the west side of the river. Exotic shapes and themes were popular for filling stations of this era. (Courtesy of The History Center.)

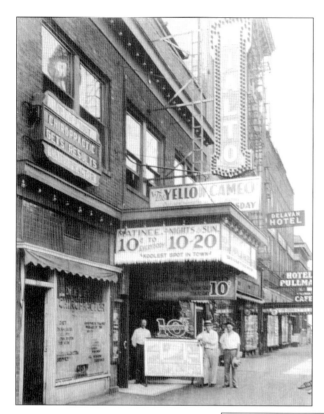

The Rialto Theater, shown here in 1931, opened in 1906 as the Delphus Theater. The Rialto was the first movie theater in Cedar Rapids. The original moving pictures shown were educational or travel films. Admissions cost a nickel Monday through Saturday and a dime on Sunday. After another name change, the building was torn down about 1954. (Courtesy of The History Center.)

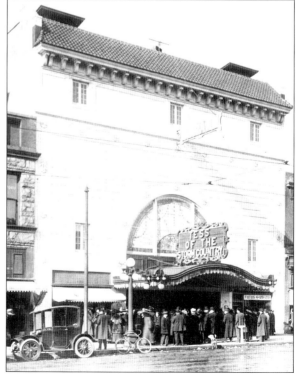

The Strand Theater opened in 1915. Cedar Rapids first professional stock acting company, the Strand Players, played there, as did other vaudeville acts. After silent pictures came out, the Strand started showing these too. The Strand changed its name to The State in 1929, and became The World in 1960. The c. 1920 photograph shows the crowd gathering for the next show. The building had light bulbs in each of the medallions on the building as well as between the cornice brackets. (Courtesy of The History Center.)

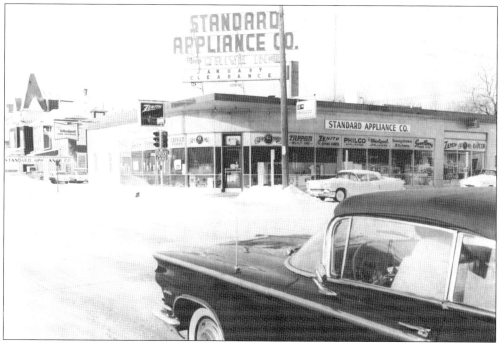

In the early 1950s, the Standard Appliance Company came on the scene at the NW corner of Second Avenue and Tenth Street SE. It carried brand-name appliances of the major manufacturers and was the first in town to advertise and carry the "radar range." The photograph is of the store as it appeared in 1963. (Courtesy of George T. Henry.)

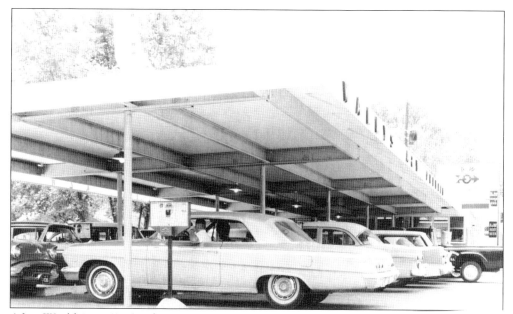

After World War II, the drive-in restaurant became very popular. Pictured here is Wally's A&W Root Beer Drive-In on Ellis Boulevard NW as it appeared in 1963. The drive-in opened in the early 1950s and since 1984 has been the only drive-in in town. Its appearance has changed little since 1963. (Courtesy of George T. Henry.)

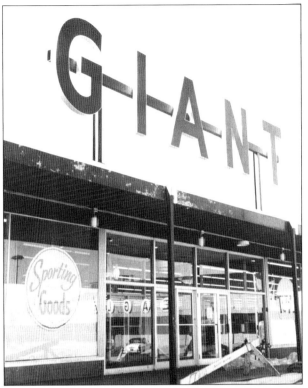

This photo depicts the Giant Store as it appeared in 1964. It was located in the shopping center at 16th Avenue SW and Williams Boulevard and had an active but rather short life. The store offered many different products and services. It later became Jack's and then Shopko, before it closed. (Courtesy of George T. Henry.)

One of the services offered to the customers of the Giant Store was a beauty shop. This 1964 photograph shows beauty shop patrons drying their newly styled hair, after which they could continue with their shopping. (Courtesy of George T. Henry.)

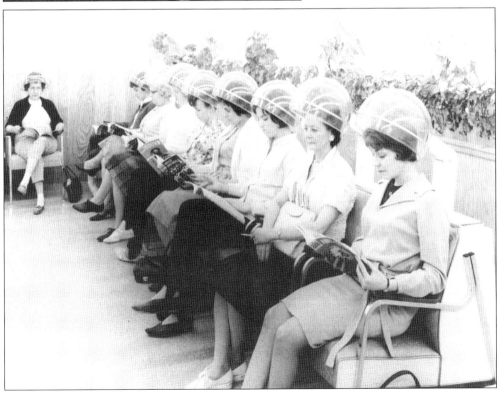

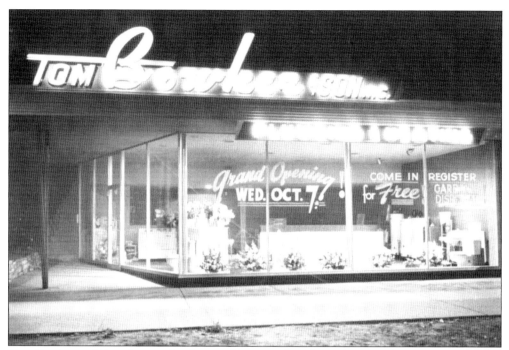

Tom Bowker and Sons Inc., a plumbing and heating shop, hosted its grand opening on October 7, 1952. The business was located at 1314 First Avenue NE. It provided repair and installation of residential and business plumbing as well as other services. (Courtesy of The History Center.)

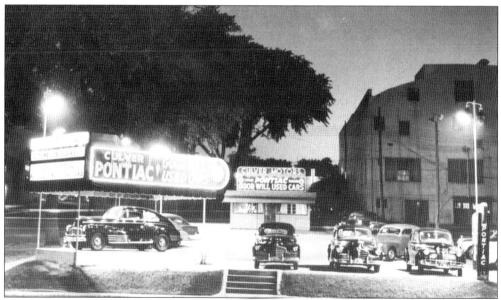

There were many automobile dealerships on First, Second, and Third Avenues—close to downtown. The Culver Motors used car lot was located at 700 Third Avenue SE, one block east of their dealership at 601 Second Avenue SE. This 1950 photograph shows the brightly lit used car lot at night, showing off the shiny cars. (Courtesy of The History Center.)

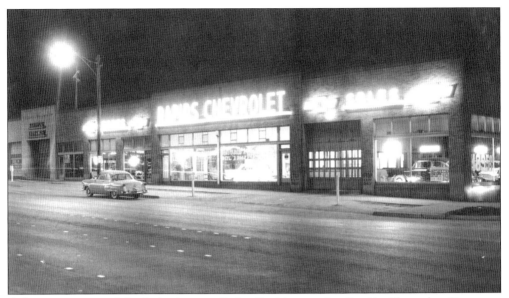

A longtime automobile dealership in Cedar Rapids was the Rapids Chevrolet Company, operated by the Fletcher family. Here is a night shot showing the building at First Avenue and Sixth Street SE, where Chevys were sold and serviced from 1935 to 1990. The History Center remodeled this building and moved there in 1999. (Courtesy of The History Center.)

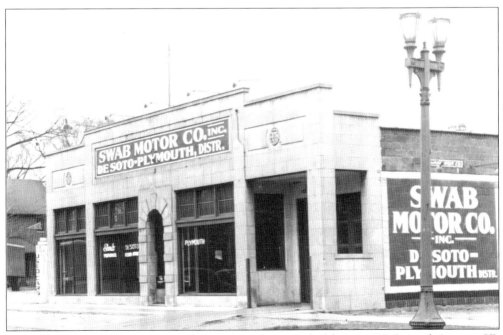

This 1947 photograph shows the Swab Motor Company building at 829 Second Avenue SE. Swab Motors handled Plymouth and DeSoto cars. Next to the dealership is the company's used car lot. (Courtesy of The History Center.)

Eight
TRANSPORTATION

Most of the dramatic changes in Cedar Rapids history had to do with transportation. The small-market economy changed rapidly to a large industrial economy with the installation of the rail lines. The rail lines also meant the building of magnificent passengers depots, like the BCR&N and Union Station, both of which brought to the city thousands of visitors and new residents. Streetcars, trolleys, buses, automobiles, and eventually airplanes offered residents increasingly efficient ways to travel to other urban areas like Waterloo, Iowa City, Chicago, Omaha—and beyond.

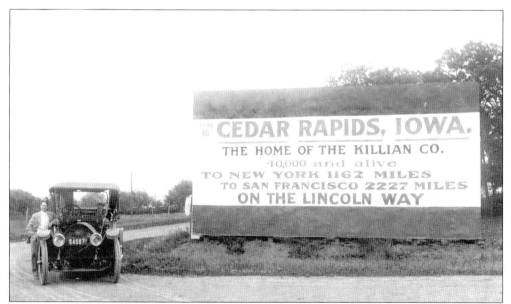

As the Lincoln Highway was conceived and laid out about 1913, there were no paved and few graveled roads. In many cases there were no roads at all, but by 1915 the Lincoln Highway was in place. If you were an adventurer, had a reliable car, could keep the car running with repairs, could fix flats, and were blessed with good weather, you could drive across the country. (Courtesy of The History Center.)

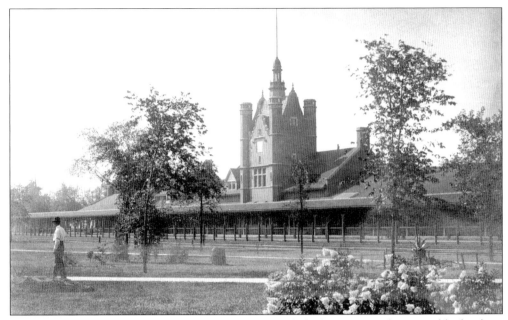

Union Station was completed in 1897. Its structure and platforms covered two city blocks along the Fourth Street tracks from Third Avenue to Fifth Avenue. The magnificent station, with a clock tower and two restaurants, was designed to demonstrate to the world that Cedar Rapids was a first-class rail city. At one time the station accommodated as many as 99 passenger trains a day. The station fronted along Greene Square Park, offering a beautiful vista for the traveler. (Courtesy of The History Center.)

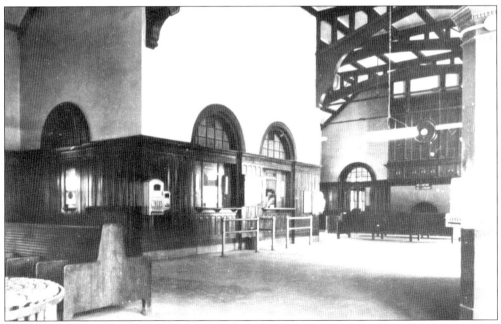

The interior of the station was majestic with the high ceilings, polished wood, brass rails, and open floor space. Here it is shown in 1961, shortly before it was torn down. (Courtesy of The History Center.)

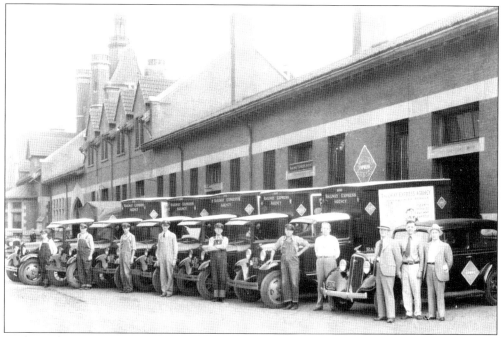

In the early 1930s, the Railway Express Agency was the fast way to get packages delivered. Trucks picked up the packages as soon as they arrived by train and delivered them to their destination. Here the drivers and their trucks line up on the Third Street side of Union Station. (Courtesy of The History Center.)

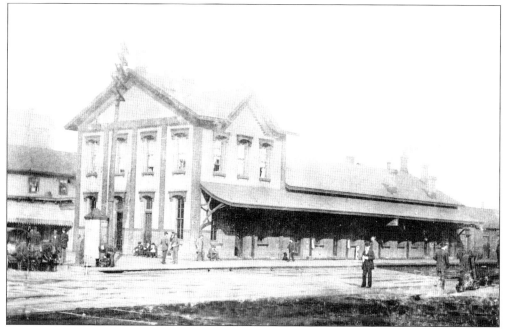

This c. 1900 photo shows the Chicago & Northwestern Depot on the corner of First Avenue and Fourth Street. The platform runs along the Fourth Street tracks. The station was flanked by hotels for the convenience of the passengers. (Courtesy of The History Center.)

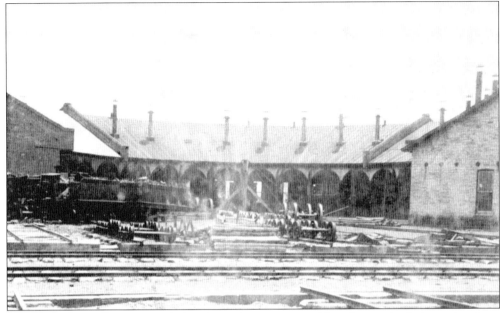

The railroad roundhouse provided a place where trains could go for repair, fittings, cleanings, and other needed adjustments. This c. 1900 photo shows the interior of the roundhouse on the northeast side of town, toward Cedar Lake. A turntable was set into the ground in the center of the structure and could be turned to run the locomotive or car into one of the many repair bays. (Courtesy of The History Center.)

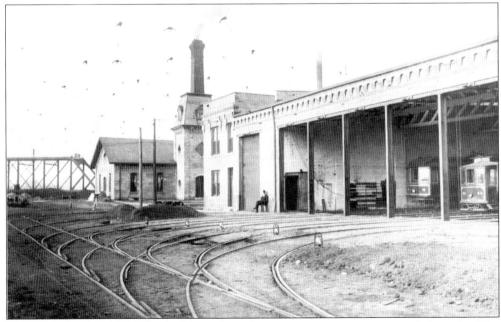

Streetcars were routed to this building when they were not in service or needed repairs. The Street Railway Barn, shown in this c. 1900 photograph, was located at the end of Second Street NE. The water treatment plant smokestack can be seen in the background. (Courtesy of The History Center.)

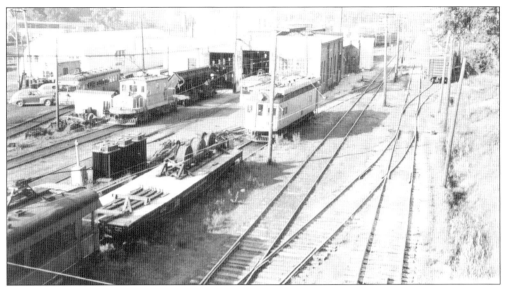

This 1953 photograph documents the Cedar Rapids and Iowa City (CRANDIC) railyards as seen from the 16th Avenue SW viaduct, near Rockford Road. The CRANDIC began electric passenger train service between Iowa City and Cedar Rapids in 1904. The side-to-side motion of the train made for the popular slogan, "Swing and sway the CRANDIC way." Those same motions also lead to more unkind names. (Courtesy of The History Center.)

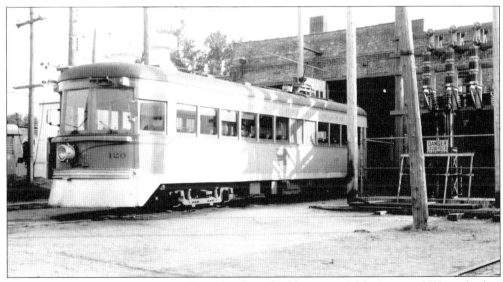

CRANDIC Car No. 120 emerges from the shops building near 16th Avenue SW on the last day of passenger service, May 30, 1953. (Courtesy of The History Center.)

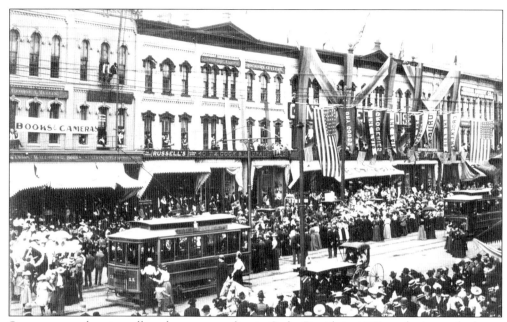

Streetcars, or electric trolleys, became a reality in Cedar Rapids in 1891, replacing mule drawn converted wagons that contained ten seats. The new trolleys had a top speed of 35 miles per hour and 14 miles of track. Two streetcars are shown on the First Avenue tracks between Second and Third Streets on parade day about 1905. (Courtesy of The History Center.)

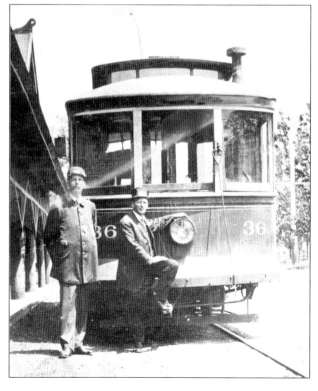

Streetcars went to all parts of the city with stops and turnarounds at the outlying terminals. Two conductors are shown with their trolley at the Bever Park Station about 1900. (Courtesy of The History Center.)

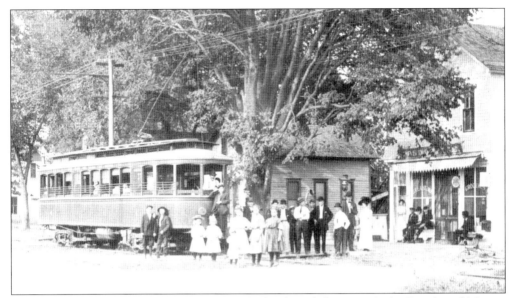

The Kenwood Trolley Depot was a stop "on the boulevard" between Cedar Rapids and Marion in the early 1900s. A crowd of passengers waits to board the trolley at First Avenue and 32nd Street SE. (Courtesy of The History Center.)

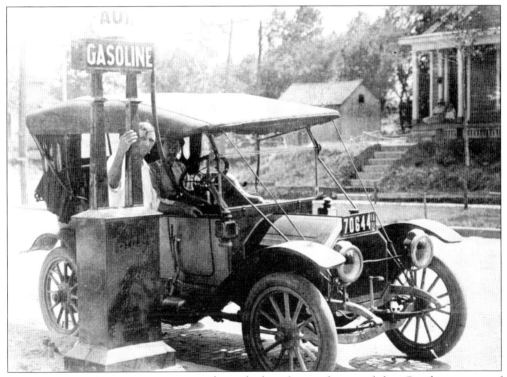

Gasoline pumps became a common sight with the advent of automobiles. Gasoline pumps of that era were operated manually by the service station attendant, who also washed the windshield and checked the oil. In this 1914 photograph, an employee fills his tank while the owner remains inside. (Courtesy of Dorothy Johnson.)

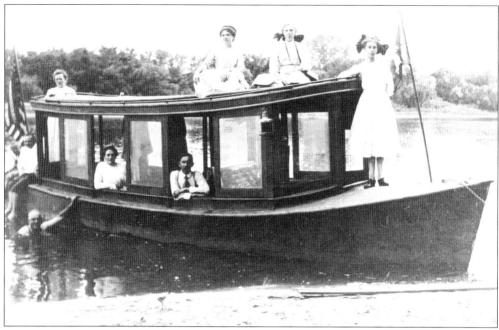

In the early days, watercraft traveled the river to transport both people and goods. This era was short-lived, and the river was largely given over to pleasure crafts. One of the excursion boats is shown near Ellis Park about 1915. (Courtesy of Dorothy Johnson.)

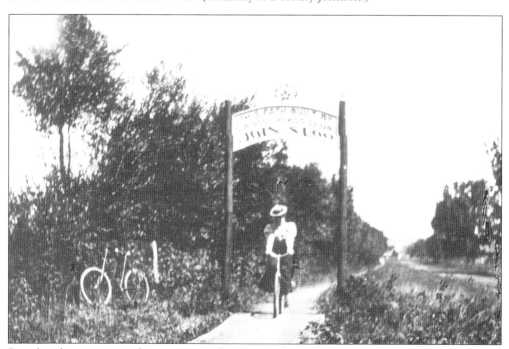

Bicycling became a popular pastime in the 1890s. The Good Roads Club built a bicycle path along the Cedar River, as shown in this 1902 photograph. A bicycle path along the streetcar tracks between Cedar Rapids and Marion was built about 1895, and bicyclists could go between the cities in 19 minutes. (Courtesy of The History Center.)

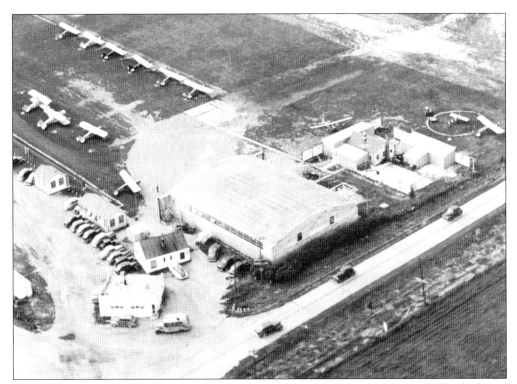

Hunter Field opened in 1924, near what is now Highway 30 at Bowling Street SW, which was then three miles from the city. The airfield served as the municipal airport, providing service for both private and commercial airplanes. Dan Hunter of Cedar Rapids was a World War I aviator in 1919, and soon established himself as a civilian pilot and stunt flyer. (Courtesy of The History Center.)

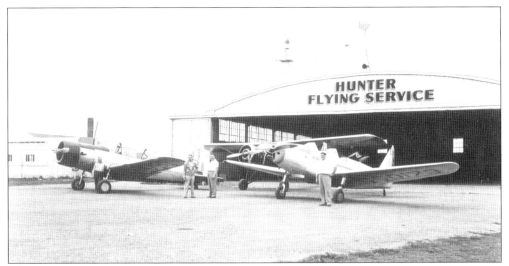

In addition to serving as the municipal airport, a student could receive flying lessons through the Hunter Flying Service. During World War II, Hunter Field became a headquarters for the War Training Service pilot program. The school had a good reputation for safety. (Courtesy of The History Center.)

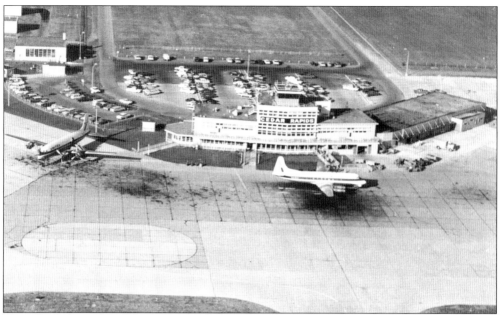

Although Cedar Rapids citizens had previously voted down bond issues to build a new municipal airport, in 1942 they voted "yes" to the construction of new facility. The first service by United Airlines was started on April 27, 1947. A passenger flying into the Cedar Rapids Municipal Airport in about 1965 would have seen this view. (Courtesy of The History Center.)

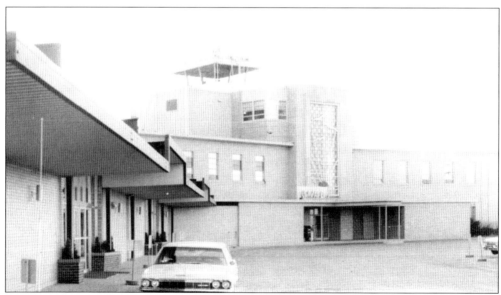

A farmhouse served as the original passenger terminal, but a new building was completed in 1953. Passengers departing from the Cedar Rapids Municipal Airport would have used the terminal entrance shown in this 1965 photo. (Courtesy of George T. Henry.)

Nine
RIVERS AND BRIDGES

The Cedar River provided both transportation and power for the early settlers. The first dam built on the river was built in 1844 and the first bridge across the river was built in 1856 at Seventh Avenue. A toll bridge was erected at First Avenue in 1859. The charges were a penny for a pedestrian or more for a vehicle and team. The river challenged several generations before it was completely tamed without floods. The Cedar River was revered not only for its production powers for the great mills and factories, but also for its great beauty as it curved around the city and off into rural parks and farmland.

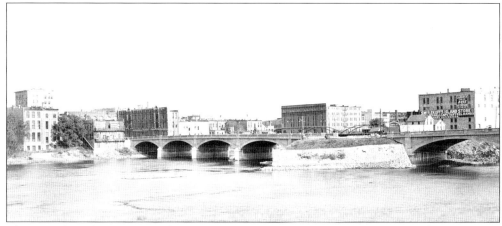

This view faces down river to the Second Avenue Bridge, which was constructed in 1906. The bridge as constructed had eight spans, a 30-foot wide roadway and two six-foot wide footpaths. It was said to be the finest structure of its kind in the country. (Courtesy of The History Center.)

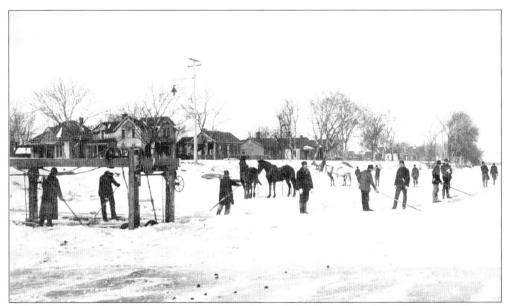

Before freezers and ice machines were invented, people had to either do without ice, or harvest and store ice from the wintry environment. The ice of the frozen Cedar River was cut into long strips in the dead of winter. Each strip was cut into 200-pound cakes. The conveyor belt at the left moved the ice from the river into the icehouse. This c. 1900 photo shows workers cutting blocks of Cedar River ice. (Courtesy of The History Center.)

Once the conveyor had moved the blocks of ice into the insulated icehouse, they were covered with straw and kept for summer use. A customer purchased ice by the pound for use in the icebox by putting a card in their window requesting the number of pounds they would like delivered. This c. 1900 photograph shows the Chadima Brothers Icehouse, owned by Joe and Thomas Chadima. (Courtesy of The History Center.)

C.P. Hubbard established an ice business in 1870 under the name of Hooper and Hubbard. In 1882, Hubbard became the sole owner of the company, which was incorporated as the Hubbard Ice Company in 1902. This c. 1910 photograph shows the huge Hubbard Ice and Coal Company storehouse, with the conveyor belt on the left. In 1922, the Chadima Brothers merged with Hubbard Ice, which continued under that name. (Courtesy of the Chadima Family.)

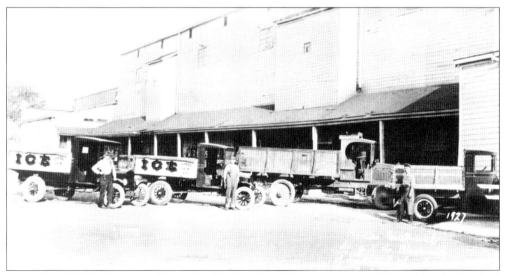

In the late 1920s, ice was delivered in Hubbard Ice Company trucks. The vehicle bodies had been converted into trucks by the company blacksmith. Children would tag after the ice trucks on hot days, hoping to scavenge chips of ice. (Courtesy of the Chadima Family.)

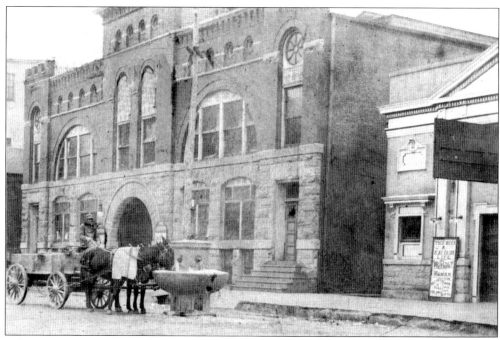

When the predominant mode of transportation in Cedar Rapids was the horse, certain things needed to be supplied for their convenience, such as hitching posts and horse watering tanks. This *c.* 1900 photo shows the horse-watering fountain on First Street NE between First and A Avenues, in front of the Auditorium and the Peoples Theatre. (Courtesy of The History Center.)

Drinking fountains were also supplied on the sidewalks for thirsty humans. The Daughters of the American Revolution dedicated a fountain at 305 Second Avenue SE. The water needs of Cedar Rapids were first supplied by a private company using sand filters with a capacity of 2.4 million gallons per day. The city purchased the system in 1903 and in 1923 placed the waterworks under the city council's direction. (Courtesy of The History Center.)

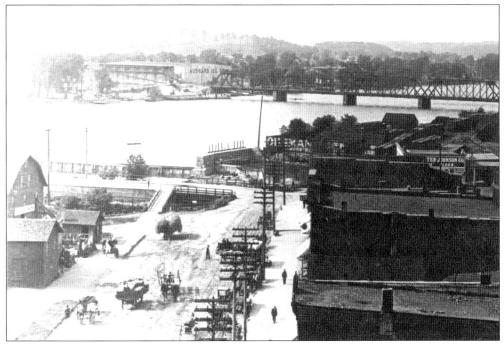

In the left foreground of this 1895 photo is the F Avenue Bridge, which was actually in line with B Avenue on the east side of the river. In the background is the Chicago and Northwestern Railroad Bridge. Across the river is the Hubbard Ice Company icehouse. (Courtesy of The History Center.)

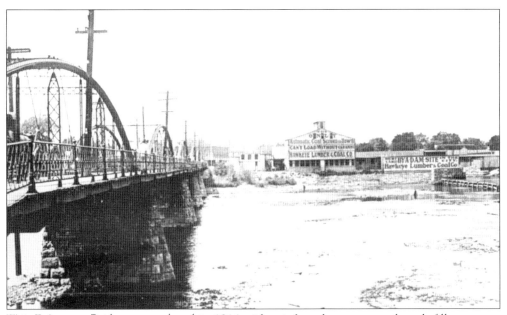

This F Avenue Bridge was replaced in 1914 with reinforced concrete and earth-fill structure. The nine-span bridge had a 42-foot wide roadway and two eight-foot wide sidewalks. At the west end of the bridge is the billboard with the famous slogan "Best yard in the city by a dam site," advertising Hawkeye Lumber. (Courtesy of The History Center.)

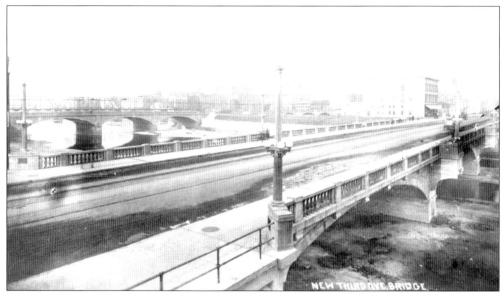

The Third Avenue Bridge, built in 1911, is shown shortly after its completion. In 1907, the city council proposed to issue bridge bonds for constructing new bridges at 16th Avenue and B Avenue. An additional bridge was added to the proposition because of a petition submitted by prominent businessmen who wanted a new concrete bridge at Third Avenue to provide an additional access point to downtown. Consequently, the Third Avenue Bridge was added to the bond. (Courtesy of The History Center.)

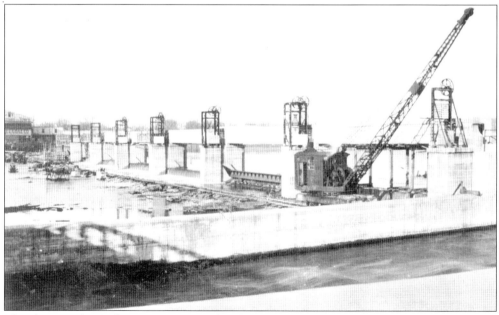

This dam on the Cedar River was completed in 1918 and consisted of a reinforced concrete superstructure with steel floodgates. The dam was anchored into the limestone bed of the river and provided a steady water supply for industrial and recreational use. This structure remained in service until the Five-in-one Dam was built in the late 1970s. (Courtesy of The History Center.)

Ten
RECREATION IN
CEDAR RAPIDS

From expansive public parks to parades and carnivals, the citizens of Cedar Rapids have always emphasized recreation and entertainment. Founding American families were generous with the donation of land for public parks. The river also provides opportunities for boating, fishing, and swimming. Semi-professional baseball has been a part of the city for over 100 years. A zoo and an amusement park were part of the city's early history.

As travelers looked out their train windows upon arrival at Union Station in Cedar Rapids, they were welcomed by Greene Square Park. In addition to providing a beautiful gateway to the city, the park was used by many residents for a stroll. Throughout its history, the park has boasted a fountain, a cannon, a bandstand, and lovely landscaping. (Courtesy of The History Center.)

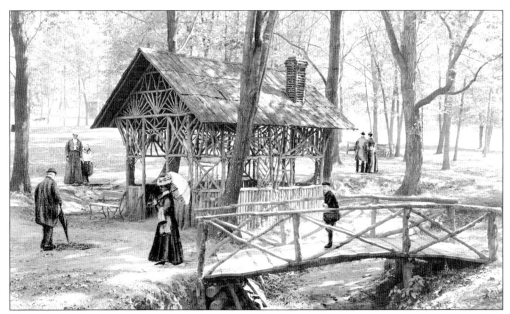

Bever Park, donated by the Bever Family, covers many acres in southeast Cedar Rapids and is enjoyed by thousands of people each year. The park featured rustic shelters and bridges as seen in this c. 1900 photo. Because of its popularity, a streetcar stop at the park was instituted. (Courtesy of The History Center.)

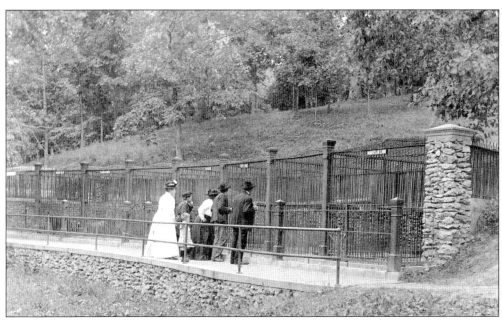

Bever Park was known for its unique zoo, which included a bear pit in the early years. This photo from about 1900 shows the variety of other animals found in the zoo. Over the years visitors have enjoyed monkeys, lions, foxes, lynx, badgers, and other animals. (Courtesy of The History Center.)

Ellis Park was purchased from the Ellis family in 1901, with additions made throughout the years. The shelters and bridges of the park were rustically constructed of natural rock. A relaxing way of spending the day was to take a drive through the park with a horse and carriage. (Courtesy of The History Center.)

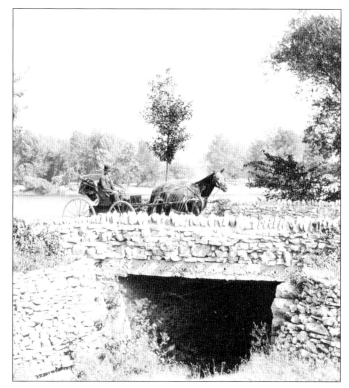

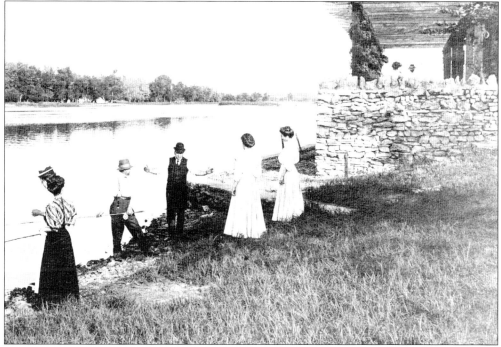

Another way to enjoy Ellis Park was to take advantage of its waterfront. Here, men and women line up along the shore, while Cedar Rapids photographer William Baylis (center) exaggerates the size of the fish he caught. (Courtesy of The History Center.)

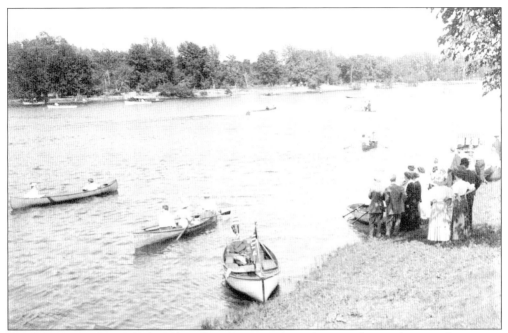

The lagoons at Ellis Park also allowed enthusiasts to rent boats and enjoy boating. Swimming beaches were for those more daring. In the 1940s, a swimming pool was added to the park for safer swimming. (Courtesy of The History Center.)

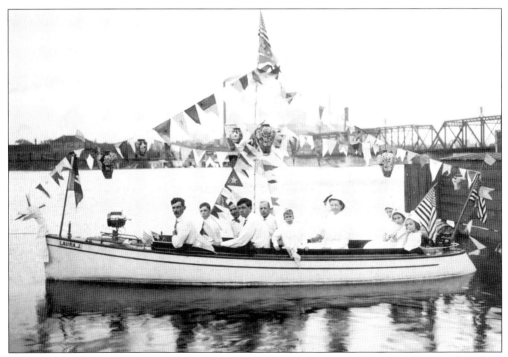

At the turn of the 20th century, boating was a popular pastime. Here the *Laura J* is taken for a jaunt on the river. She is decked out with pennant flags and the passengers are decked out with paper hats. The prow is decorated with a dragon's head. (Courtesy of The History Center.)

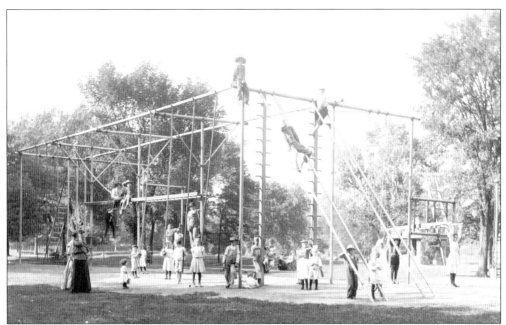

Riverside Park, established in 1894 on C Street SW, was Cedar Rapids' third park. The park was equipped with a playground containing a huge piece of climbing equipment as seen in this c. 1900 photograph. The top of the equipment is at least 12 feet off the ground. A community building was added to the park in the 1960s and most recently a skateboard park. (Courtesy of The History Center.)

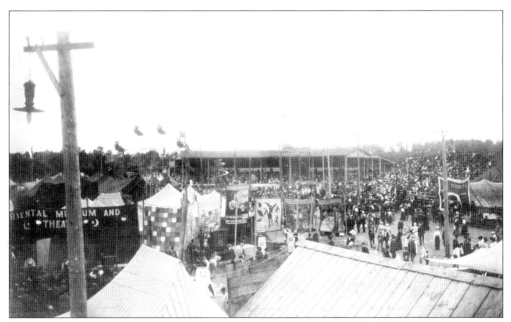

Cedar Rapids' popular amusement park, Alamo Park on 13th Street NW, was located on 18 acres and opened in 1906. It contained a roller coaster, Ferris wheel, merry-go-round, roller rink, dance pavilion, and many paths and walkways. (Courtesy of The History Center.)

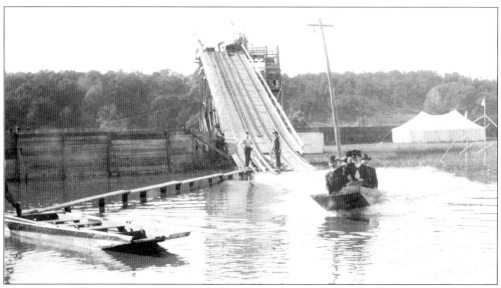

Shown here at Alamo Park is the Shoot-the-Chutes noted as one of the "longest and highest electric chutes in the country." (Courtesy of The History Center.)

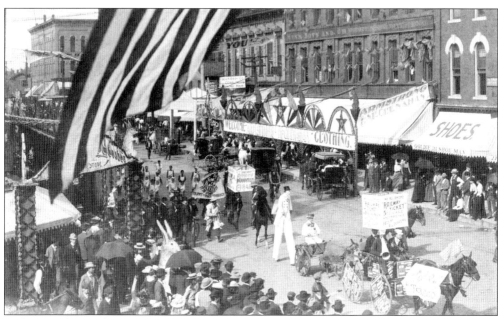

Cedar Rapids has always loved a parade. During the early 1900s, the city sponsored an October Carnival. Chief among its attractions was the Floral Parade with the marching bands, tissue paper-covered automobiles, and clowns. This photo taken about 1906, shows the downtown buildings all dressed up for the parade with flags flying, and large "rabbits" mingling with the crowd. (Courtesy of The History Center.)

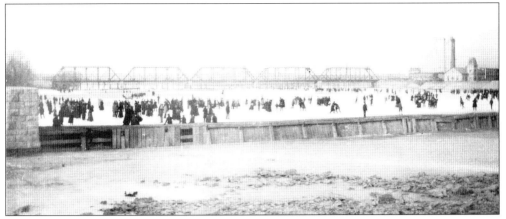

Wintertime in the late 1800s was enjoyed by skaters on the Cedar River. The old wooden dam allowed the water to be backed up, forming an admirable skating rink on the river. (Courtesy of The History Center.)

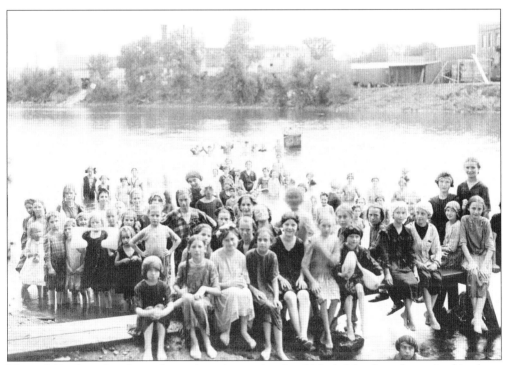

The girls' bathing beach was located on the south side of May's Island, as shown in this photo taken in the early 1900s. The girls are wearing a variety of swimming clothes and most a cap of some sort, yet none of them are wearing bathing shoes. (Courtesy of The History Center.)

Organized baseball arrived in Cedar Rapids in 1890, when the club was admitted to the Iowa-Illinois Professional Baseball League. Belden Hill Park is where the team, the Cedar Rapids Bunnies, played ball. Hill Park was near Alamo Park. (Courtesy of The History Center.)

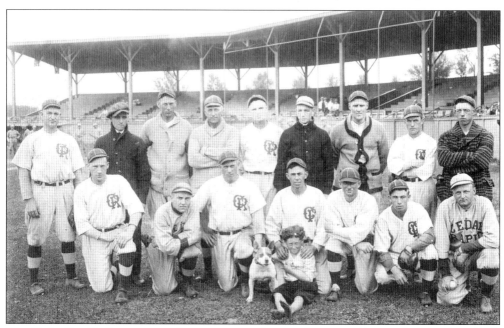

The Cedar Rapids Bunnies pose for a picture in their stadium near Roosevelt School in 1915. The manager was Jack Herbert. Included on the team was C.A. "Runt" Marr, who later became a St. Louis Cardinals baseball scout. The photo is complete with a mascot and a dog. (Courtesy of The History Center.)

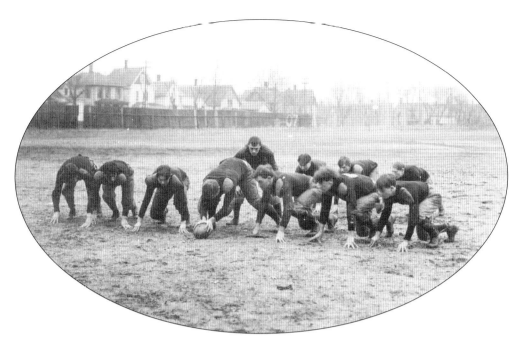

Another team sport enjoyed by Cedar Rapidians was football. Here the Coe College football team plays on their field about 1900. College football continues to be important today. (Courtesy of The History Center.)

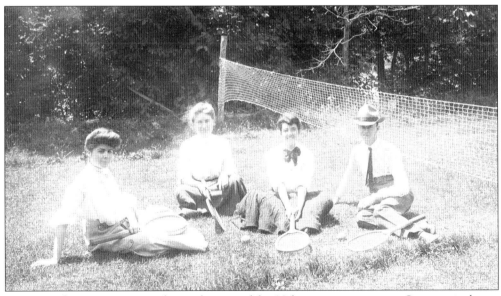

One sport that women engaged in at the turn of the 20th century was tennis. One man is shown here with three women players on a grass court. Tennis clothing for the women does not differ much from their everyday clothing. Note that the man is wearing a tie. (Courtesy of The History Center.)

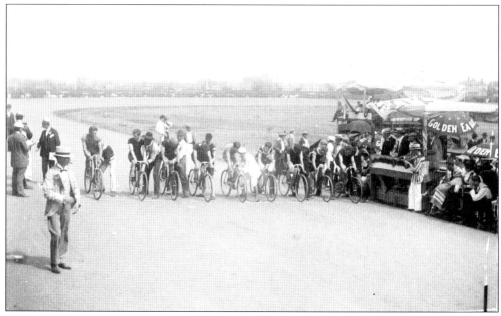

Because of the popularity of bicycle riding, races became all the rage. Here, cyclists line up to start the race at Cedar Rapids Driving Park near Alamo Park. (Courtesy of The History Center.)

Bicycles also furnished funny parade entries. These boys have camouflaged their bicycles as horses. (Courtesy of The History Center.)

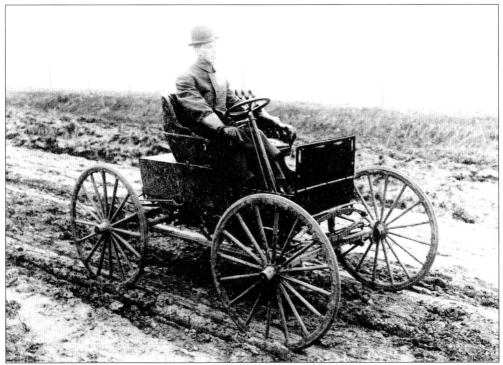

After the automobile gained popularity, the Sunday drive became a staple in the lives of those with cars. Road conditions did not always allow the drives to be enjoyable. (Courtesy of The History Center.)

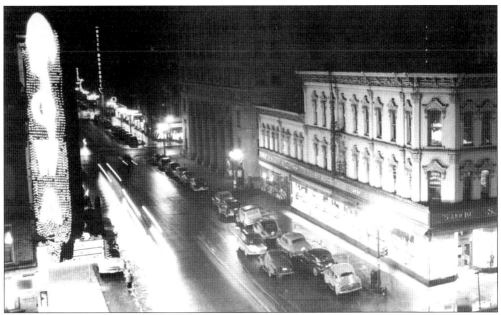

In the 1950s, a cruise around downtown was a fun way to spend the evening. Going to a movie was also popular. The sign for the Iowa Theater was shaped like a huge ear of corn, with 3,570 green and yellow light bulbs. (Courtesy of George T. Henry.)

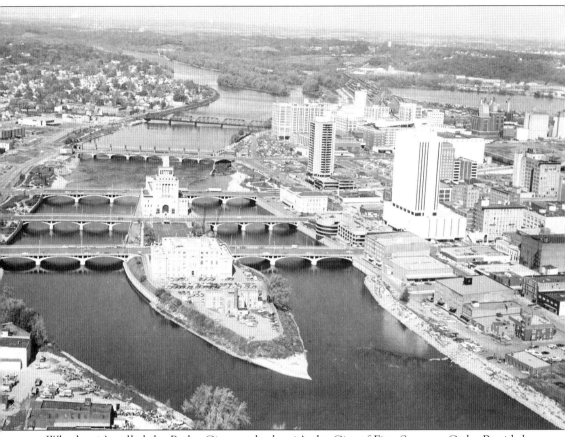

Whether it's called the Parlor City or whether it's the City of Five Seasons, Cedar Rapids has all the advantages of a large city, but retains the comfortable home-town feel that could be found 100 years ago. (Courtesy of The History Center.)